Charles Reid
Master Class
PAINTING
by DESIGN

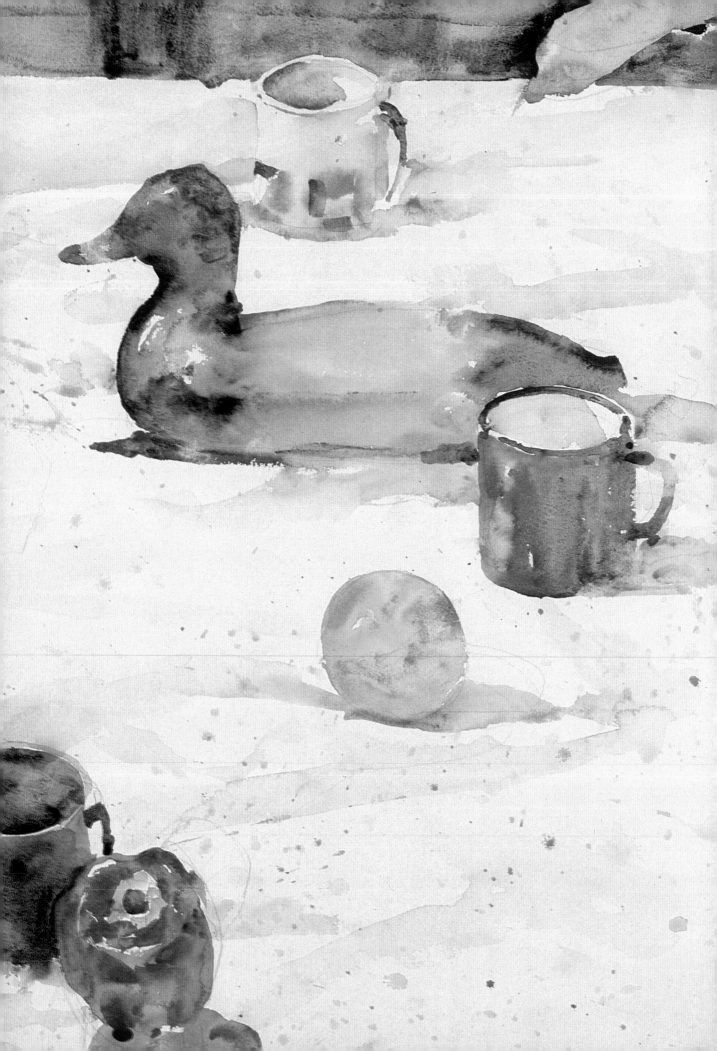

Charles Reid
Master Class
PAINTING
by DESIGN

Watson-Guptill Publications
New York

ACKNOWLEDGMENTS

Where would Thomas Wolfe have been without Maxwell Perkins? Where would I be without Marian Appellof?

Thanks must also go to Jay Anning for the book's handsome design; to my friend Brian Lanker for his extraordinary pictures; and to Vin Greco for his fine photographs of my paintings.

First published in 1991 in the United States by Watson-Guptill Publications, a division of BPI Communications, Inc., 1515 Broadway, New York, NY 10036.

Library of Congress Cataloging-in-Publication Data

Reid, Charles, 1937–
 Painting by design : master class / Charles Reid.
 p. cm.
 Includes index.
 ISBN 0-8230-3587-5 (cloth)
 1. Painting—Technique. I. Title.
ND1500.R375 1991
 751.4—dc20 90-23571
 CIP

Manufactured in Singapore

First printing, 1991

1 2 3 4 5 / 95 94 93 92 91

All watercolor paintings in this book were done on paper.
Photographs on pages 14, 15, 18, 19, 20, and 30 by Brian Lanker.
All artworks in this book are in private collections unless stated otherwise.

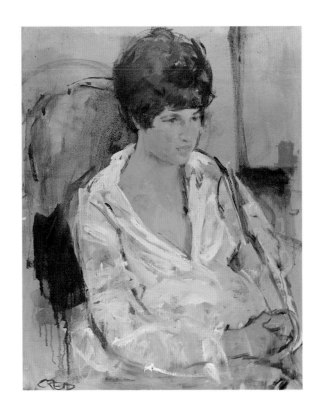

For Judith:

Permit me voyage, love, into your hands . . .
 −Hart Crane

CONTENTS

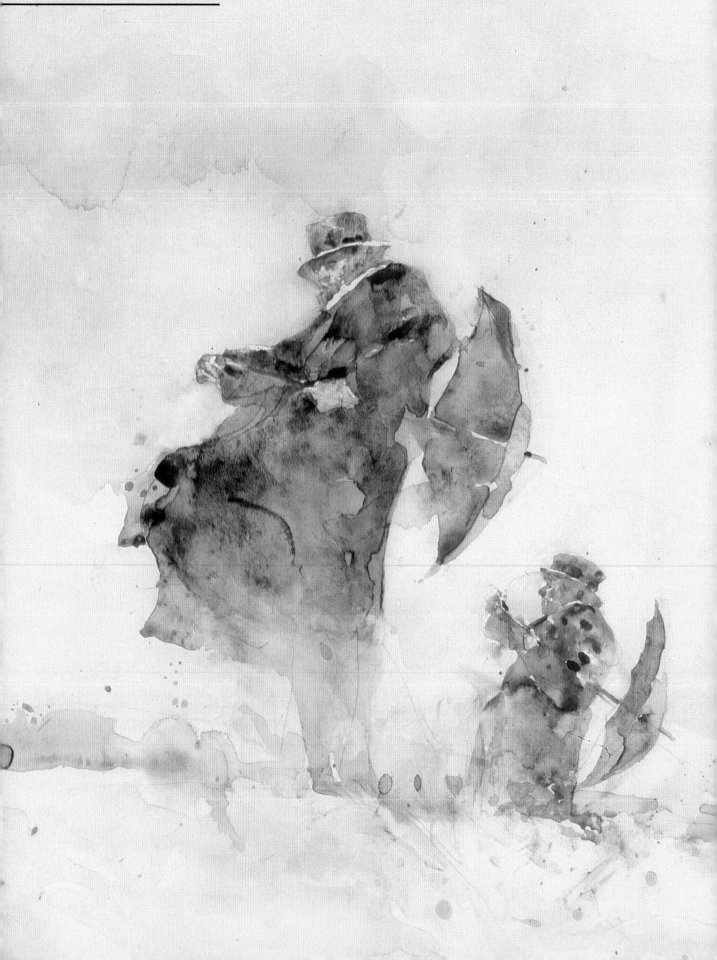

EDITOR'S NOTE

Editing a book by an artist and teacher who is as tireless and as passionate about painting as is Charles Reid was no easy endeavor—but then, I came away with plenty from the collaboration. I got to participate in his workshops, if only vicariously, for several months' running, and to look intensively at hundreds of his artworks in context. Charles made me think hard about what goes into making good art; may he have the same effect on all his readers.

–Marian Appellof
Senior Editor

INTRODUCTION

I like to think of this book as a one-room schoolhouse that offers something to everyone no matter what level of artistic surehandedness you've reached or what medium you prefer. Every workshop I teach is composed of people whose skills, visions, and backgrounds vary widely, yet from the midst of all that diversity comes a single desire: how to make good paintings.

Painting is first and foremost about *seeing*. In *Painting by Design*, it's my aim to get you to do just that: to see any subject you choose as a set of very definite shapes of color, light, and shadow. Forget what your subject represents, be it a fruit bowl in a still life setup or a model in a figure sketch class; concentrate instead on what it *is*: just a shape, a piece of a puzzle or part of a pattern that's meant to be arranged in some compelling way with other shapes. Master that ability, and the instincts that tell you how to create interest, variety, depth, and even mystery in your work will begin to fall into place.

The book consists of six parts: Drawing, Color & Value, Light & Shadow, Figures, Faces & Features; and Designing Paintings. Each contains exercises I've used in workshops or devised anew especially for the book, as well as finished paintings that illustrate how I apply the principles I teach in my own work. Rather than describe here what's to follow, I'd like you to simply plunge in. Start with the first two chapters, then look ahead to whatever interests you. Then look at everything all over again, slowly. I hope you'll see more each time.

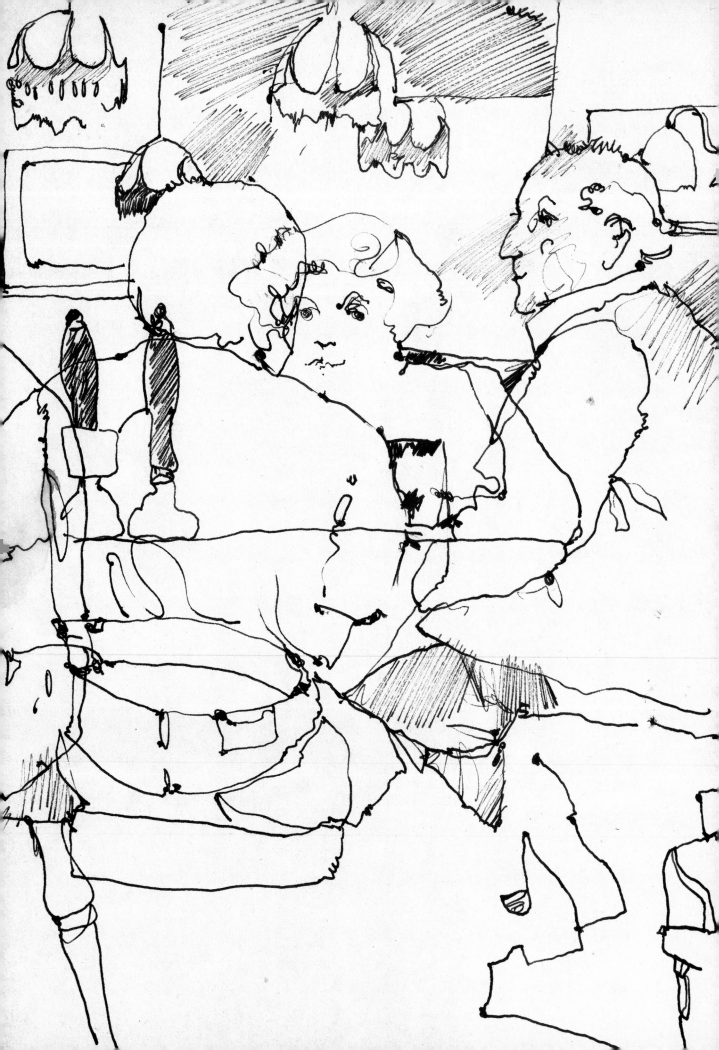

Part One
DRAWING

The thoughts we explore through drawing are at the very core of the painting process. In this chapter, I outline two approaches—contour drawing and rhythm drawing. In terms of pen and pencil handling they're quite different, but in terms of thinking, they have a lot in common: Both require seeing, not just looking. By this I mean delving beneath the surface of what's in front of you, getting beyond your mind's preconceptions about your subject. Both approaches demand a sense of variety; repetition is out. You have to develop the ability to interpret figures, shapes, lines, and patterns as elements that can be arranged into interesting, eye-catching two-dimensional designs.

CONTOUR DRAWING

This is an especially good technique for those who haven't done a lot of drawing, yet even though I draw constantly, I still use contouring in all my sketchbook work. It's a great teacher.

In contour drawing, geometry is critical. We must see angles, distances, and shapes of curves, all without the aid of rulers and compasses. I'd like you to start training your eye and hand to take the place of such tools. We're going to do a series of exercises, beginning with drawing an apple. This will take interest and concentration; I hope you'll get so intrigued, so consumed with the simple problem of drawing an apple that you'll forget all else. Your sole goal in life will be to draw the consummate apple.

You'll need an apple, a drawing pad that measures about 14 × 17 inches, and a pen of your choosing. Don't use pencil or charcoal: I don't want you to erase or correct.

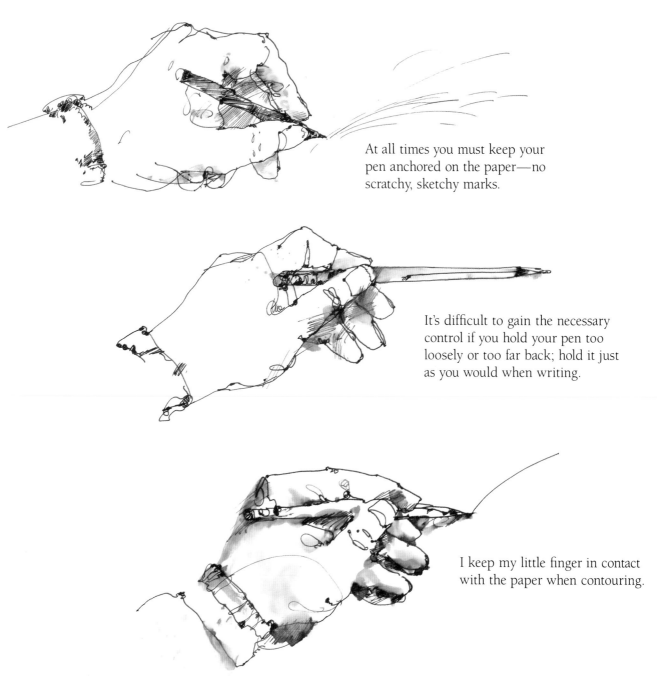

At all times you must keep your pen anchored on the paper—no scratchy, sketchy marks.

It's difficult to gain the necessary control if you hold your pen too loosely or too far back; hold it just as you would when writing.

I keep my little finger in contact with the paper when contouring.

To begin, place the apple on a surface at about eye level. Draw a horizontal line across your paper from one margin to the other.

Draw your first apple toward the left end of the line. Concentrate; try to draw your apple as accurately as possible. Make sure you keep the pen on the paper at all times.

Draw your second apple next to the first. This time use only angles—no curving, rounded lines. The idea is to make a definite change in direction on the paper each time your eye detects a direction change in the apple's silhouette. It's vital that you concentrate and draw very, very slowly. Study my drawing and note that I make a dot marking a new direction for my pen.

The first drawing is fairly symmetrical—the shapes are repetitive. I can draw lines from points on one side of the apple to corresponding points on the other and end up with a series of parallel lines. The second drawing has different shapes on either side of the form, so that any lines connecting one side to the other would have to be diagonal. The lesson here is, symmetry makes for boring drawings, and you should avoid it. We're not talking about producing identical objects on an assembly line.

Do several "dot-to-dot" apples. Keep some of your lines and angles straight and let in a few curves, but not too many; then try using more curves and fewer angles. Try long, almost curving lines with some short jogs. You'll see that no two of my apples are exactly alike. Change your tempo as you draw: Slow down as you do angles, and speed up a bit as you do straight lines and curves.

With any luck your most successful attempts will be those that have the most variety and least repetitive shapes. Like an Oriental rug, your drawings may have the appearance of symmetry but on close examination should open up an abundance of subtle variations.

If you were able to do the apple exercise well, you should be able to draw almost anything as long as you understand that it's all a matter of concentration and seeing *shapes*.

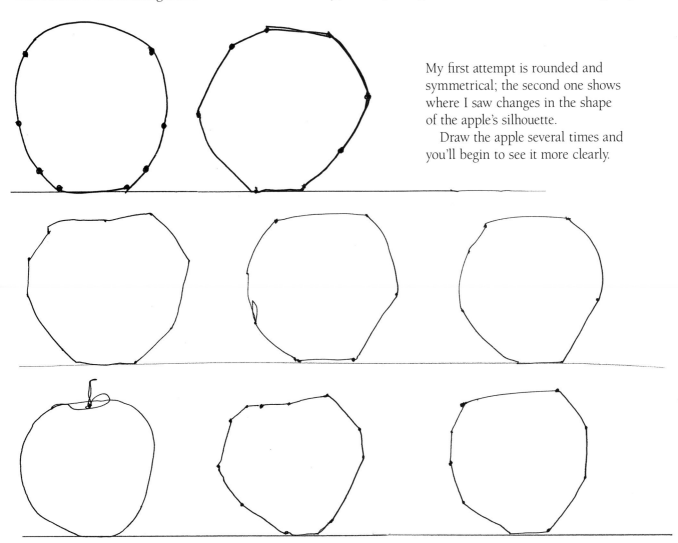

My first attempt is rounded and symmetrical; the second one shows where I saw changes in the shape of the apple's silhouette.

Draw the apple several times and you'll begin to see it more clearly.

SEEING SHAPES

Drawing the silhouette of a head is perhaps a bit more challenging than drawing an apple, but relies on the same basic principles. For this exercise I've chosen a profile with lots of shape changes (this is actually a photograph of the American politician Alf Landon). I want you to learn to draw from shapes, to draw *abstractly*.

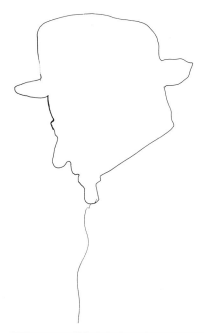

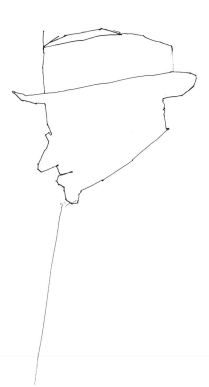

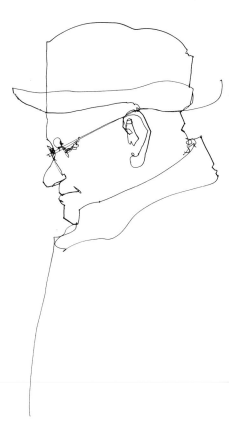

Draw the silhouette as you normally would.

Now draw it without curves, only angles. This will go very slowly. Really concentrate. Pretend your pen is on the photo, not on the paper.

Combine your curves and angles. Remember to slow down at angles and speed up a bit at the curves and straight lines. No shape should repeat itself. You're drawing *shapes*: Don't get hung up trying to draw an accurate, "good" nose. Instead, let your pen be your mind; if you simply concentrate, your pen will give you the expressive image you're after.

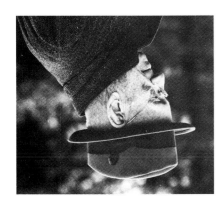

Learning to see and draw shapes abstractly takes some time, perhaps because most of us think in terms of known images. Here's the same photograph inverted—a helpful gimmick that makes the recognizable disappear and transforms the subject into simple shapes and angles, curving and straight lines. Working from an upside-down photo gives you a new perspective; it makes you see objectively, as if you were looking at something from a distance. It's not a way of drawing but simply a good way to see if you're on track.

As you look at the inverted photo, try not to think about "drawing a head"; instead, imagine you're back in geometry class and concentrate on angles and distances, pretending there's a magnet behind the photo holding your pen in place. Don't draw just the outline this time; draw *into* the features, but leave some boundaries out—you shouldn't end up with a finished drawing that's all filled in. The biggest problem will be proportions. If you concentrate on any one part you might make it too big. Everything is relative. Keep comparing the distance traveled with a part you've already drawn, and keep your pen on the paper at all times.

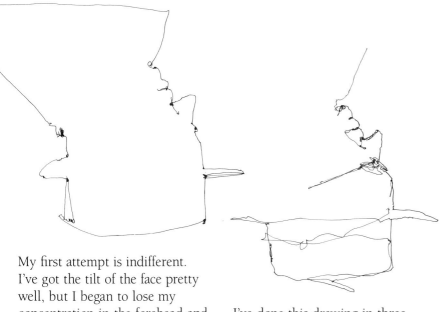

My first attempt is indifferent. I've got the tilt of the face pretty well, but I began to lose my concentration in the forehead and hat. Try again!

I've done this drawing in three steps. I want you to see how I combine the outline and the inside shapes. I draw the boundary of the *shadow* under the hat rather than the underside of the hat itself, which I can't see. This is very important: Draw only what you can see, not what you think you know but can't really see.

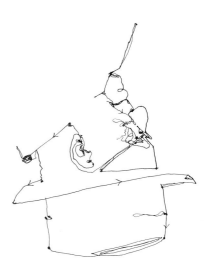

Watch the pen travel; rather than picking it up off the paper I backtrack, making a new line. The arrows show you the direction I worked in.

GETTING PROPORTIONS

Now we must draw from a "real" image: an elderly man with lots of character in his face. Here's my first attempt. Compare it to the drawings I did from the inverted photo. I think you'll agree that this drawing lacks character. It's too "normal." I've lost the tilt of the head and glasses. I've lost the character I accidentally managed to capture in the inverted drawings because I'm now drawing from my mind rather than my eyes. I'm able to make a decent drawing of a head simply because I've drawn a lot. The angle of the glasses is a giveaway. Because we tend to want to draw things on the horizontal or the vertical, without the kind of practice I've had over the years, I would never have drawn the glasses with this much of a tilt. The trick in really *seeing* your subject is to maintain objectivity.

As you draw the man's face, think of weaving, of attaching neighboring forms as you draw. Think of all elements as being interconnected. Start with the eye, completing each component in this order: lids, socket, iris. The eye will be your measuring tool for the proportions in the rest of the face. Getting the correct angle for the bow of the glasses is also critical. Stay within a confined area. Proportions become impossible if you wander too far from reference points. Make several drawings of the eye and glasses. Try not to think of what you're drawing; think instead of shapes, angles, and distances, just as when you drew the subject upside down.

Each of the three drawings you see here is different. Note how I tried to correct the angle of the glasses in the example at right. I keep my pen working in place to create dark areas.

Make several drawings of these few features before attempting the whole face, devoting complete concentration until you're satisfied with the results. Take comfort in the fact that your artistic ancestors had to draw from plaster casts for a whole year before they ever saw a live model.

COMPLETING THE CONTOUR

Let's get on with the rest of the face. It's really not important what route you take, as long as you follow these general guidelines:

- Concentrate.

- Use angles and curves.

- Keep your pen on the paper at all times.

- Go slowly at angles; speed up at curves and straighter lines.

- Describe shadows within definite, contained shapes.

- Stop often, keeping your pen anchored, to compare and relate a new form to one you've already drawn.

- Leave some boundaries incomplete. Your pen should weave adjacent forms so separations can't always be found.

My finished drawing contains mistakes, as yours probably will. The important thing is to accept them as part of the work.

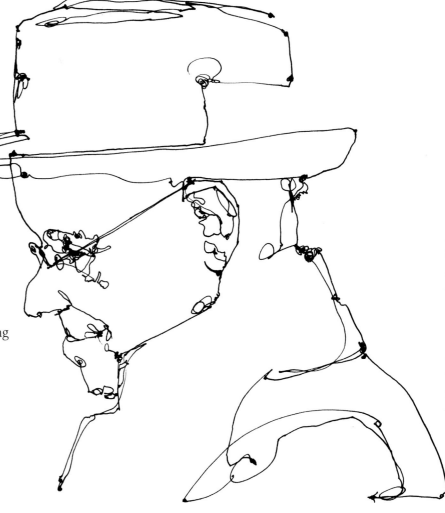

CONTOURING FOR EXPRESSION

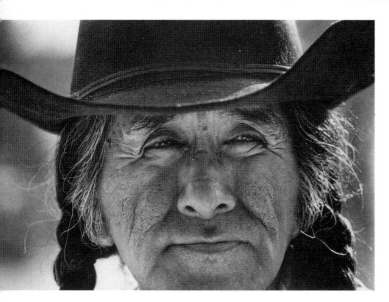

Let's look at more contour drawings based on some striking photographs by Brian Lanker. I've left them incomplete so you can see my path as I draw. My aim is to show you that contouring can help you see your subject more clearly and render it more freely and expressively. Look at this photograph of an American Indian, then look at my contour drawing below.

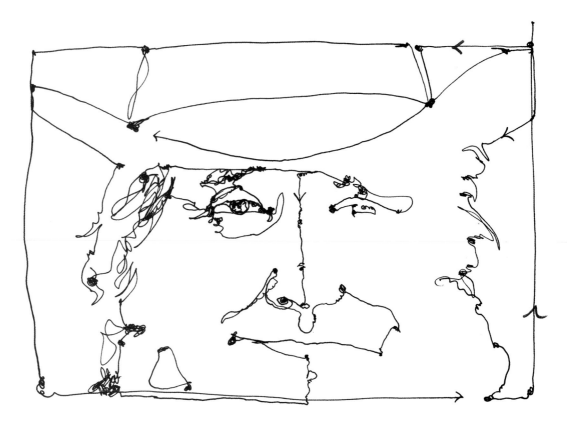

Note how my pen travels—almost at whim rather than bounded by the "fences" formed by the face, hat, and hair. Notice that I've rendered one side of the face with more detail than the other. The contours on the left side are completely different from those on the right.

This is a wonderful photograph, one that triggers ideas and interesting interpretations. We can't improve on the photo itself—it's too good—but we can make a new image, a different image inspired by it. My efforts seem to be rather lighthearted. How do you see this photo as you draw? Try not to have a preconceived idea; simply draw using the contour techniques I've outlined. Let your pen tell you what you think: It won't work if you tell your pen what to do, it'll only work if you concentrate on the image and keep your pen on the paper. Try to be open in your mind but controlled in your hand.

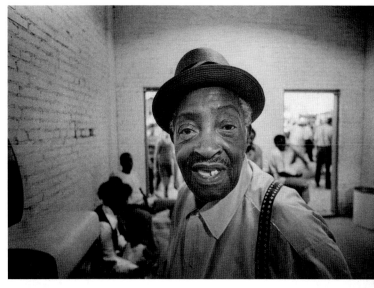

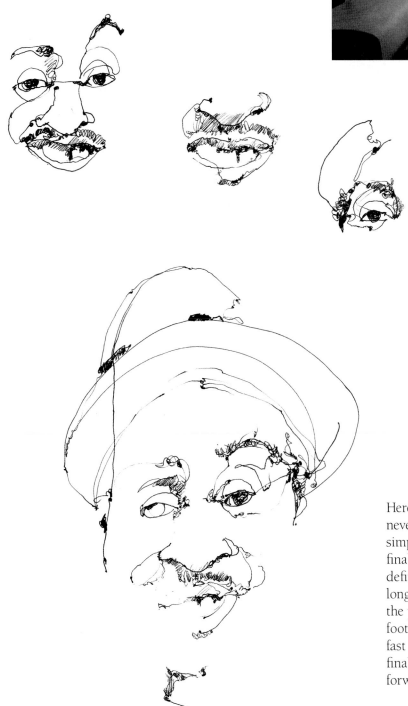

Here are a few more technical pointers: I try never to repeat a shape, and I vary from a simple, extended line to small loopy lines, finally contrasting the simple lines with definite darks. Varying your line is easy as long as you remember to keep the pen on the paper. Think of a jogger, whose footprints are far apart when he's running fast and become denser as he slows down, finally overlapping as he stops moving forward but maintains the tempo in place.

FROM CONTOUR TO RHYTHM DRAWING

In contouring, we related each new thought to an adjacent one. When we stopped to check angles, directions, and proportions, we used a neighboring line or form as our reference. When our line hit a new form, we followed a new direction. Rhythm drawing is a somewhat different approach that involves longer, flowing lines and less emphasis on interconnecting adjacent areas—we're no longer so concerned with "weaving" forms together.

Switch to a pencil; it's a bit more sensitive than a pen. Any medium-soft pencil will do. Keep the eraser out of sight.

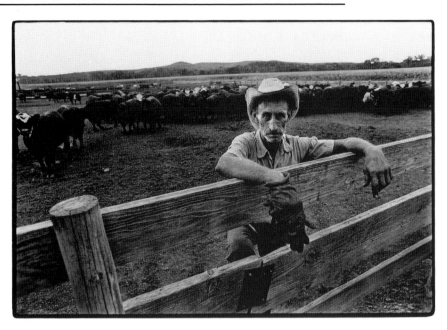

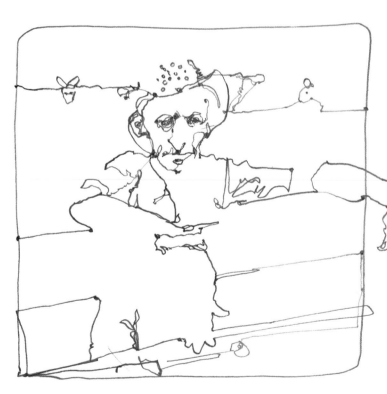

Here is a contour drawing based on the photograph. Notice that I've made a border. It's important to contain your drawing, but if you can't fit everything in, feel free to cross over the border as I've done with the arm. Note, too, how my pencil meets new forms and forgets about the old ones and travels off in a new direction. What about the distortions in the huge hands and the unfinished face and arms? Can you allow yourself to do this? Turn the book and look at the photo upside down if you find yourself being too tidy and correct. Try a few inverted drawings, then try again right side up.

Now I'd like you to try the same subject using rhythm drawing. Begin with this exercise. This drawing method requires a free-arm motion. (Your hand or little finger won't be in contact with the paper as they were when you were contouring.) Start with the head. Make some simple ovals at different angles like the ones you see here. Keep your lines long and flowing—no short jabs. The lines don't have to connect. I usually go down one side, top to bottom, then repeat the stroke on the other side.

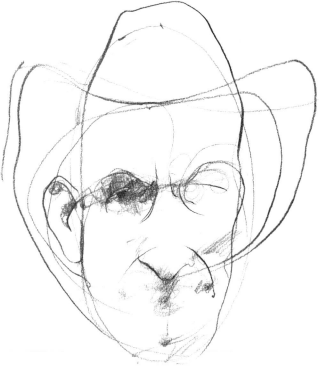

As in contouring, I want you to draw the features early on. I start with my freely drawn oval, then, using circular strokes, I map out feature placement. We're approximating, not pinning anything down. I'm thinking of both eye sockets. Notice how far down the face I've placed them (students often place them too high). Notice, too, the line I've drawn crossing over the bridge of the nose. Don't think of the eyes separately from each other or from the nose. Next I sketch the shadow under the tip of the nose. Even if there wasn't an obvious shadow there, this is what I'd use to indicate the length of the nose, not vertical lines. I've shown a long nose and a short chin. The mouth is done with a long loop, then a short loop for the shadow under the lower lip. I'm thinking only of horizontal forms, like the rungs of a ladder down the face.

The second drawing shows my next step. I want you to see how forms connect across boundaries. Note how the face extends up toward the crown of the hat, how the right side of the brim connects to the tip of the nose, while the left side of the brim ties in with the chin line. Look for other relationships. As you attempt similar drawings, strive above all for variety. Try to see the weight in some of my lines as I press down and *carve* with my pencil. You should be able to see where I lighten pressure and my hand keeps moving but the pencil lifts slightly off the paper. Finally, notice my shading. Study the direction of the strokes: They run diagonally to the lines describing the face.

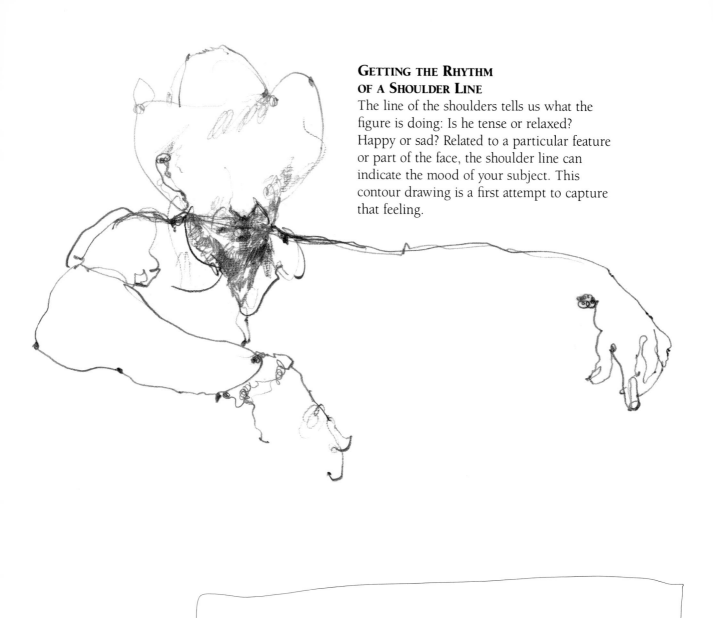

GETTING THE RHYTHM OF A SHOULDER LINE

The line of the shoulders tells us what the figure is doing: Is he tense or relaxed? Happy or sad? Related to a particular feature or part of the face, the shoulder line can indicate the mood of your subject. This contour drawing is a first attempt to capture that feeling.

In these four cartoon figures, I've drawn the shoulder line through the face so that you can see how it relates to the rest of the head and to the features. It should be fairly obvious how important it is to establish this relationship if you hope to convey the spirit of the figure's gesture accurately.

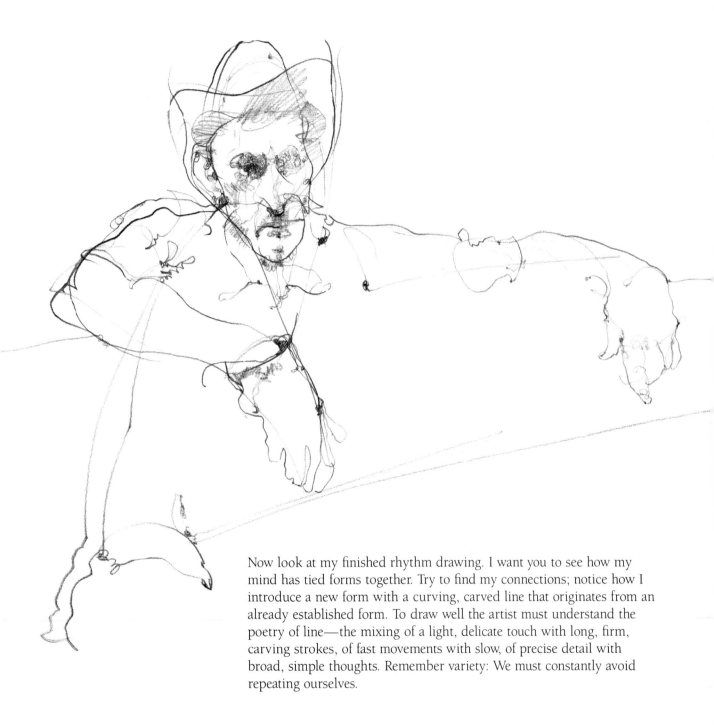

Now look at my finished rhythm drawing. I want you to see how my mind has tied forms together. Try to find my connections; notice how I introduce a new form with a curving, carved line that originates from an already established form. To draw well the artist must understand the poetry of line—the mixing of a light, delicate touch with long, firm, carving strokes, of fast movements with slow, of precise detail with broad, simple thoughts. Remember variety: We must constantly avoid repeating ourselves.

GETTING A FLUID LINE

I did this contour drawing to show my class the next step: how to achieve a more fluid line. This time I used Conté pencil, moving it more quickly than before but still keeping it anchored to the paper. Shapes are more exaggerated and less accurate, as I'm now mainly concerned with catching the spirit of my subject. This stage of drawing is a joy.

JON AND KRIS
Conté pencil on paper, 34 × 28″ (86.4 × 71.1 cm).

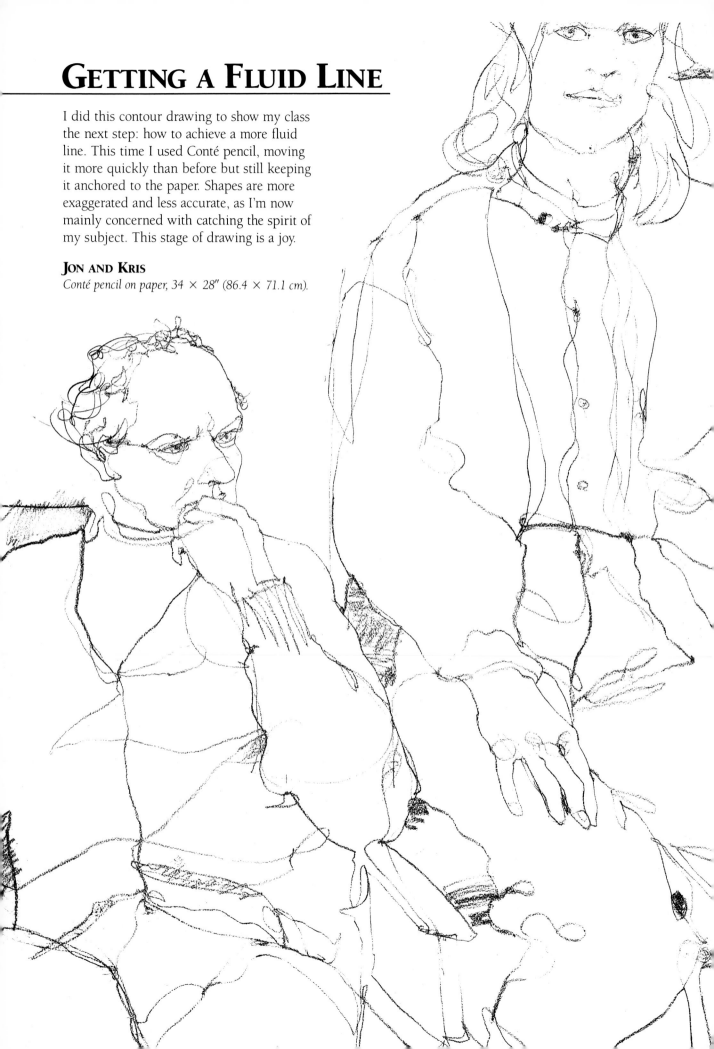

Contouring can be wonderful fun, but as you improve you'll probably find the drawings a bit static. I did the large drawing at left not as a "how to" demonstration but simply to show the spirit of line that's possible with practice.

Just as before, I continued to think of my pencil's trip through and around the figures and negative shapes. Notice the shaded block between Jon's upper arm and Kris's elbow: I used this negative shape to help me get their relative positions correct. I started with Jon's eyes and worked down the nose to the hand. I went back to the corner of the right eye and traveled over to the ear, then into the hair, concentrating on getting the forehead the right size and shape. When Jon was finished, I found a place on his arm to make a loop over to Kris's hand. I completed the hand, then worked upward toward the head. This can be tricky; to make things easier, you could do a light silhouette drawing like the one at right as a guide.

Note that I crowded my figures. I started with Jon's head and made it about one fifth the length of my paper, which was about 34 inches long—in other words, Jon's head measures about six inches.

Composition was not much of a consideration in this particular demonstration. Accidental compositions are often the best. Small heads and figures are the hardest to render because they're so constricting; I stress making figures large in relation to picture size. Your purpose is to render your subject, so let it dominate. If you're attracted to the surroundings and want to make them a vital element of your composition, that's fine, but be sure to consider your commitment

to the background before you give it space you might regret later.

You'll see that my drawing has definite outlines. If I were to paint over it, I'd probably want to fill it in—it's too rigid to serve as a painting guide. Drawing like this gives me great pleasure and loosens my hand and mind. It makes me more prepared for painting. It makes me aware of *shapes*. In other words, it's an end in itself yet prepares me for the next step.

MOVING TOWARD PAINTING

The ability to draw well with enthusiasm is essential if you hope to paint the figure successfully. Contouring is a great way to learn, but it has a big drawback: Boundary lines are definite throughout, and it's hard to make the connections between adjoining forms that are so critical in the painting process. In fact, the very essence of painting is the combination of *connection* and *separation*.

As you begin to make the transition to painting, you have to pay more attention to distinctions between positive and negative shapes, shadows and cast shadows, backgrounds and foregrounds, and between what's definite and what's obscured.

Squint very hard at your subject. If it's easy to see a separation between two shapes, you'll have a separation in your drawing or painting. If it's hard to see a

separation, you'll have a "lost" boundary, and the background and figure will seem combined into a single shape. Usually areas of different value will look separate, while areas of similar value will be connected. With repeated practice, you'll start thinking instinctively of the figure and background in terms of shapes that are defined more by value relationships than by physical categories. You'll see more *obj*ectively and less *subj*ectively.

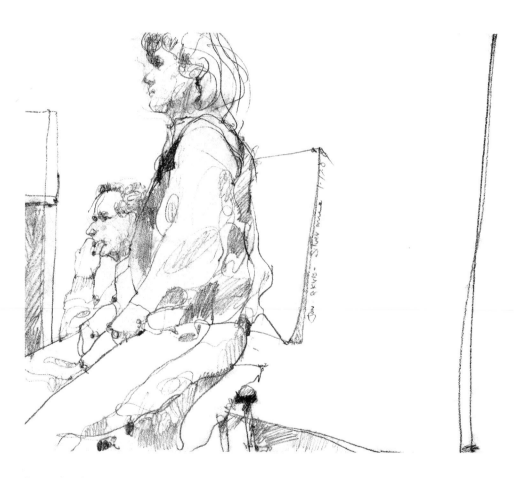

JON AND KRIS
Conté pencil on paper, 24 × 18″ (61.0 × 45.7 cm).

This is another view of the models you saw on the previous two pages, but now I'm thinking in terms of painting. Notice how I've used shading to connect the two figures. Can you see that I've used shading equally in the figure and in the background? In other words, I don't concentrate just on the figure, leaving the background alone. I draw them at the same time, with equal attention and emphasis.

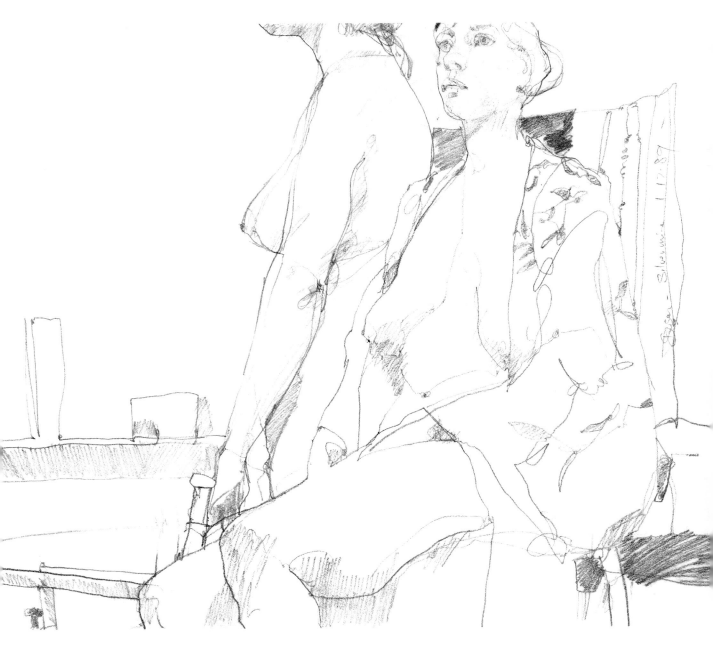

TWO VIEWS OF SUSAN
Conté pencil on paper,
18 × 24" (45.7 × 61.0 cm).

I asked Susan to sit for the class for a twenty-minute pose, then stand for the next twenty minutes. The contained circular shapes you see here are my way of mapping out the specific boundaries of shadows and cast shadows. In some cases these two kinds of shadows seem distinct from one another—most prominently in the arm of the standing figure—while in almost all other places they form a single connected shape; in the right-hand figure, study the knee and upper leg where it meets the calf. My shading lines run diagonally across the figure boundaries so I can connect two forms. In the seated figure I did this in the legs and in the right breast and robe.

Notice how important the darker background shapes are in bringing the figures into focus. Sometimes the background (negative) shapes are separate from and in obvious contrast to the figures; in other places the background shapes ignore boundaries and simply overflow into a figure shape. Look especially at the back of the standing figure and the neck of the seated figure.

VALUE SHAPES

Most beginners have trouble thinking of values and colors as shapes; the tendency is to identify physical objects first, then add the colors and values. Take a painting you like and turn it upside down. I think you'll see that part of what you like about it is the specific arrangement of dark and light colors and shapes—the abstract elements that work even when the subject ceases to be recognizable.

In painting, color is mostly a matter of personal choice, but values are factual. Before you can even consider how to use color, you must learn to see in terms of values—to see the patterns formed by light and shadow. Simply put, value means the lightness or darkness of a color measured against a scale ranging from pure white through gray to pure black. Most photographers and painters work with a scale of nine values; in my classes I find that a five- or six-value scale generally suffices.

To understand how value works, you also have to consider the nature of shadows, of which there are two kinds. *Shadows* form on the side of an object that is turned away from a direct light source. An object that's in the path of a direct, relatively strong light will *cast* a shadow. Due to reflected light, cast shadows often appear darker than shadows; and if reflected light is strong enough, shadows can appear to be as light as the actual light side of an object. Nonetheless, you should think of—and render—shadows and cast shadows as a single form rather than as two separate entities, because in composition, one good shape is better than two weak, unconnected ones.

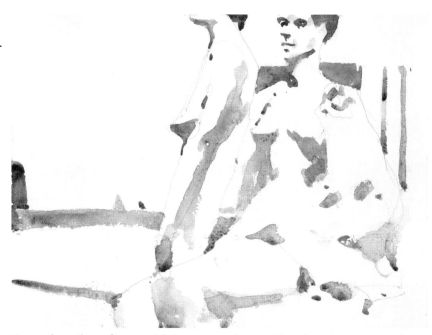

Try to describe a figure with just two values as I've done here, using the white of your paper or canvas as your light value and a single mid-dark color for shadows and cast shadows. Do you see how, with complete economy, simple, carefully designed shapes put in the right places can represent two figures?

In switching to color, the main thing is to get a value that's dark enough but not too dark. Note the two-value scale I've made in pencil at the top of the diagram; it helps me gauge the value of the color I use.

My chief concern is with my shadows, cast shadows, and negative shapes—the areas behind or around a subject. In this painting, the model's face is the light-value positive, or subject, shape; her hair becomes a darker, negative shape. *Light-value positive shapes need darker-value negative shapes*—otherwise the face wouldn't have emerged against my white background.

Ninety percent of painting problems are caused by poor value clarity and shape rather than by color. A good way to learn how to handle values is to make a six-value study of your subject in black and white like the one at the bottom of this page. In class I have students make an 8 × 10″ contour-style drawing with a value scale of six gradations from white to black beneath it. The object is to use all six values. At first, where you place them in your picture isn't as important as making sure you've actually got six gradations that "read." Value placement becomes more critical when you get to the composition stage. Values make shapes, and where you place them makes your design.

Let's look at what can happen when things go badly, as in this illustration. Perhaps your *shapes* are in the wrong places, or they haven't been carefully drawn and don't accurately describe the contours of shadows, cast shadows, or negatives; your *values* are too light, so shapes look washed out and don't "read," or they are too dark, resembling inkblots; or *edges* aren't firm and forms look mushy and ill-defined.

ASSIGNMENT

If you're working from a live model, light the figure with a fairly strong single light. If you're working from a still life, choose objects with a dull or matt surface; shiny surfaces can be confusing. Finding the main light can be difficult. Once you're concentrating on the subject, you'll start to see more and more small value and color variations. But you can't trust your eyes; they'll probably mislead you unless you decide beforehand where the main darks and lights are. Don't worry about subtleties. Remember to squint, and think of your light source. The longer you stare at an area of light or dark, the more it will look like a mid-light, but referring to a value scale will help.

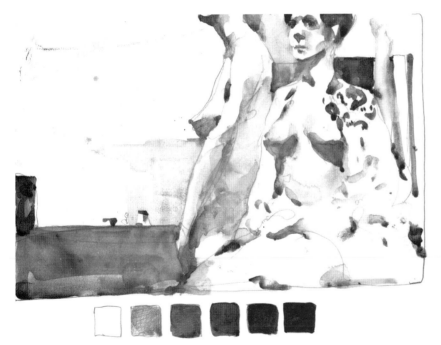

In a six-value study, it's best to use the black only as an accent, and in only one place—otherwise you could end up with a spotty-looking picture. Here, the darkest accent is on the left side of the seated model's hair, with another small one down by her leg. I like to place my dark accent next to a light value to create contrast, an effect that gives focus. Always try to have the most value contrast on the light side of your subject. Here, I made the hair the darkest on the light side and lightened the hair slightly on the shadow side. Avoid having the same value on both sides of a form. I didn't want to separate the two figures, so I also avoided placing strong darks between them.

WORKING OUT VALUE RELATIONSHIPS

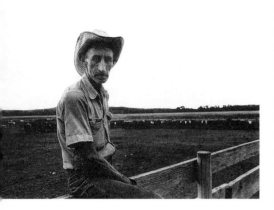

It's wise to get a sense of your subject and work out some of the problems with pencil or charcoal before you try to handle paint. Working from photographs is good practice. This is a fine photograph, though I wish the shirt were a little darker against the light sky so you could see it as more of a silhouette. Turn the book upside down and squint at the picture. Compare the lightest values in the shirt (at the hem of the sleeve and at the figure's waist) with the sky. *Never decide on the lightness or darkness of any area without comparing it first with the value of another area.* I know the sky is white, but no matter how hard I squint, that shirt sleeve still pops out. Now compare other values in the shirt with the white sky. The front of the shirt is a bit darker and seems to fade into the landscape.

Using a #2 pencil, I've done a "rough" of what I see as I squint at the image. (You could use a softer graphite pencil, or try a Conté or charcoal pencil.) My pencil developed a beveled side as I drew, so I was able to render my darks with broad strokes.

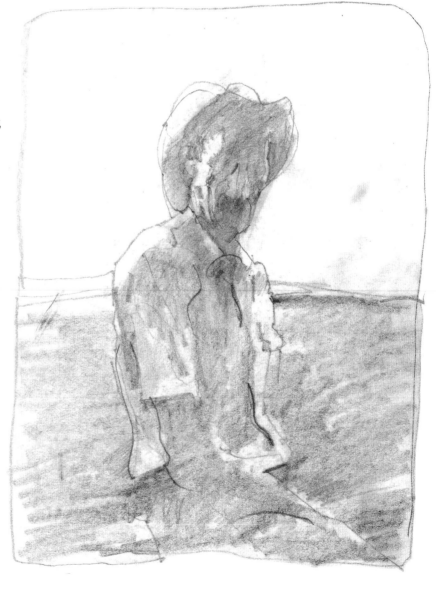

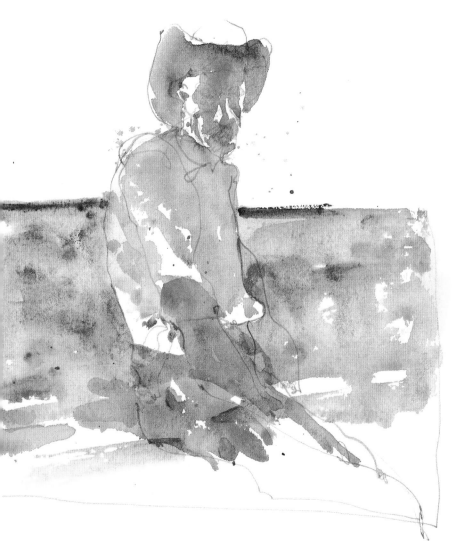

For my preliminary watercolor sketch I've used a simple palette: cadmium red, raw sienna, and cobalt blue. Even though I've painted my sketch higher in key than the photo, notice that all the values have been brought up correspondingly. I started with the figure's head and it dried a bit lighter than I wished; this meant that I had to key all of the other values to the head. The lesson here is, you must remember to paint from your painting as well as from the subject.

Let's backtrack a bit. The most effective way to capture a figure's pose is through rhythm drawing. Using a #2 pencil on vellum layout paper, I've drawn a simple but elongated oval for the head. With small, circular strokes, I sketched the features lightly as if seeing them through semi-opaque glass. This helps you get the feeling of the bulk of the skull under the small forms that make up the face. Next comes the neck, a simple tube form. The back of the neck meets the ear, while the front hits below the chin. I extend the tube as if it was sitting inside the upper torso. To the left of my drawing I've made a scale of head lengths.

Once I draw the figure's head, I measure how many head lengths there are between his chin and the seat of his jeans. Notice that the crown of his hat is an extension of the head—I draw both at the same time. Next comes the brim; I draw the sides first. The right part curves down and to the left, right through the face, and picks up the shoulder line; the left part curves down across the neck and finds the bit of shoulder on the right. Other, similar relationships are evident; for instance, the boundary of the neck on the left extends to the inside of the arm and, with a continuing curve, reaches all the way to the top of the leg.

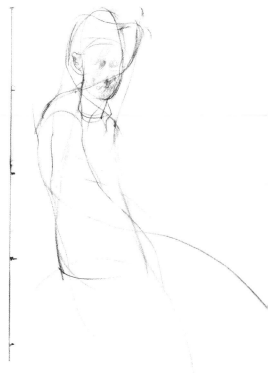

In these drawings, notice how many borders I've crossed, how many separations between forms I've lost. Note that I draw a shadow shape first, then fill it in—lightly or with a heavier hand, depending on the value I want. It's good to draw the shape first, since it gets you geared to thinking of shadows as definite shapes rather than as blurred masses. Study the directions of my shading lines. See where my pencil bears down for contrast and when it lets up, fading into an adjoining form.

Now I'd like you to use color to make your values for this silhouette, working with a limited palette of cadmium red, raw sienna, and cobalt blue. Make several swatches; just place the colors next to one another and let them mix on their own. Most sketchbook paper will do as long as it's not too thin (you don't want it to buckle). It's best to use a cold-pressed 90- or 140-lb. paper.

Concentrate on shape and on simplicity. In my sketch I haven't softened any edges; the only "lost" edges happen when I've let two adjacent areas run together. Remember our pencil work: Allow your darks to cross borders without interruption. Aim to get your values dark enough on the first try. Make sure your shadow shapes articulate the forms you see. Let your paints mix on the paper as I've done, and use only enough water to move the paint—

otherwise it will be too washed out. You should be able to see when I used my blue, red, and raw sienna alone and where I let them mingle. The top of the hat is raw sienna and cobalt; the face has all three colors. The landscape is mostly raw sienna, but note the sequence of pigment: I added the raw sienna wet-in-wet but using very little water, since my first wash, which was still wet, looked fairly bland.

Charles

Part Two
COLOR & VALUE

Color is personal, evoking as many different responses in the beholder as there are hues and combinations of hues. Each of us develops specific preferences that inform our way of seeing and handling color. But preferences aren't enough; to paint well, an artist has to understand how color actually works. One of the most important principles I stress to my students is that a color and its value—its relative lightness or darkness— are inseparable, and that learning to control what I like to call "color-values" is absolutely essential to designing effective paintings. And whatever your chosen medium—I consider watercolor and oil here—you also need to get a grasp of how various pigments interact so that you're able to mix instinctively the exact colors and values your pictures call for.

ARRANGING YOUR PALETTE

As you probably already know, red, yellow, and blue are considered *primary colors*: They can't be mixed from any other colors. *Secondary colors* result from mixtures of the primaries and consist of orange (red plus yellow), violet (red plus blue), and green (yellow plus blue). *Tertiary colors* result from mixtures of primaries and secondaries and include such hues as blue-violet and yellow-green. These relationships are most often depicted in a color wheel.

Complements are colors that lie across from each other on a color wheel—red is opposite green, yellow opposite violet, and blue opposite orange. When juxtaposed, complementary colors appear to intensify each other; when mixed, they result in grays. *Cool colors* are, generally speaking, those in the blue, green, and violet ranges; they are said to "retreat" in a painting. *Warm colors* are those in the red, yellow, and orange ranges and are said to "advance" in a painting.

Whether you're working in oil or in watercolor, you should set up your palette the same way every time you paint so you can use it the way a touch typist uses the keyboard of a typewriter—automatically, without having to search for any color.

Always place your colors around the border of the palette, leaving the center section clear for mixing. Arrange warm colors in one section and cool colors in another. Group earth colors—browns, ochres, and

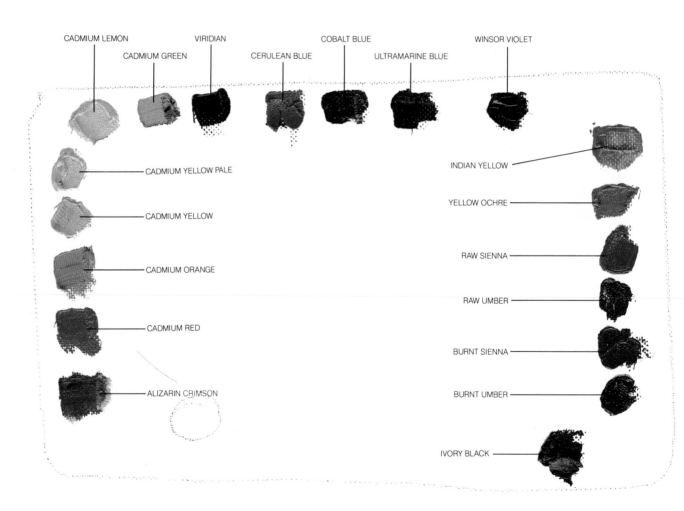

Here's one version of my oil palette. Starting at bottom left are the warm colors and, moving clockwise, the cool colors, with the earth colors along the right-hand side. I generally keep white a bit separated so it doesn't get into the color supply, and place my black at the end of the row so I don't confuse it with one of my other dark-valued colors.

the like—in a row, either in a section to themselves or between the warm and the cool colors.

Arranging colors by inherent value—relative lightness or darkness straight out of the tube—within their respective families will help you choose the right color for the value you're trying to paint and will help you avoid the mud that can result from mixing too many different colors together. We want to arrive at the desired value with as little fuss as possible. For example, if I'm painting a dark red apple, I'd go to alizarin crimson, then to the cadmium red right next

to it for rendering the lighter parts; and if I wanted to go still lighter, I'd go on to cadmium orange. If I had a dark blue that I wanted to lighten, I might start out with ultramarine or phthalo, then lighten with cobalt and finally with cerulean.

Within each color family there are, of course, warm and cool variations. For instance, cerulean and phthalo blue are cooler than ultramarine, and alizarin crimson is cooler than cadmium orange. I don't find this critical, though, at least not when you're first learning to work with color. It's more

important to find out which colors mix best with others than to worry about their warmth or coolness.

You may choose to use colors other than the ones I've listed here that will work equally well, though my earth hues are pretty standard. Color should be personal. We all react to it differently. Some artists, for instance, can't abide yellow ochre or cerulean blue. It seems to me that we find certain colors we prefer and then learn to adapt them to our way of working and seeing. Thus, you shouldn't assume that the colors suggested in any book or class will be right for you.

Here is a typical watercolor palette, arranged by color family (this time moving clockwise from cool to warm to earth hues) and, within each family, by relative value.

MIXING WATERCOLOR

Usually we find something we want to paint and then try to figure out which colors to mix. Let's reverse the process. For this exercise, you'll need a very red apple and a lemon, a good, medium-size round watercolor brush that holds water well, watercolor paper (preferably 140-lb. cold-pressed or similar), a board to place underneath the paper, and these four colors: alizarin crimson, cobalt blue, cadmium lemon, and yellow ochre.

Exercise 1. Place your paper and board flat on a table. The paint should be soft. Mix up rich, dark swatches of alizarin, cobalt, and yellow ochre (aim for the value of each color as it comes from the tube) and arrange them in a triangle. Now drop in some cadmium lemon to the ochre swatch—use very little water, since the pigment you've already put down should have enough moisture in it to absorb the yellow. You'll see that my swatches are a bit lighter than their "tube" value; always assume that a wash will dry at least one value lighter than what you put down.

Exercise 2. Arrange swatches of alizarin, cobalt, and yellow ochre in a triangle, leaving a space in the middle. Make the swatches fairly wet, but not too wet. Rinse your brush, then shake it out with a single flick of the wrist. Brush color from each swatch toward the intersection. Your brush should *move* color, not *mix* it. Once the three meet, lift your brush. The colors might need as much as two minutes' mixing time before they dry. The purpose of this exercise is to show you just how beautiful watercolor can be if you don't mess with it.

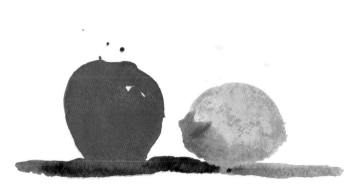

Exercise 3. Let's turn those swatches into fruit. Using alizarin crimson, make an apple shape. Then, with yellow ochre, begin the underside of the lemon, working toward the top. Before you get there, rinse your brush and do the top with cadmium lemon. Don't try to blend the colors. Now, starting on the left, run a strip of cobalt blue under the apple, then the lemon. Put down your brush and watch what happens. My apple was a bit too wet—the red flows into the blue. The ochre doesn't run as much because it's an opaque color and contains more pigment. I'm sure many of you paint great apples and lemons, but the real point here is to learn about color and water ratios.

Here are some tips on basic setup when you're painting in watercolor. As my little sketch shows, you should work on a flat surface, with your paper, water supply, and palette arranged to form a small triangle. The painting surface should be at about waist level whether you sit or stand to work.

BURNT SIENNA, RAW SIENNA, COBALT BLUE

ALIZARIN CRIMSON, ULTRAMARINE BLUE, RAW SIENNA

CERULEAN BLUE, CADMIUM ORANGE

CERULEAN BLUE, CADMIUM YELLOW

HOOKER'S GREEN DARK, CADMIUM RED

IVORY BLACK, COBALT BLUE, BURNT SIENNA

Try mixing swatches of different colors, aiming for the right amounts of water and pigment. The mixtures you see here are some that I use; substitute whichever colors you'd normally paint with so you can see how they behave. Practice placing the "pieces" of paint next to each other rather than smoothing and dabbing and fixing. Doing this should help you better understand the dynamics of watercolor: It likes to do a lot of the painting on its own.

Controlling Value

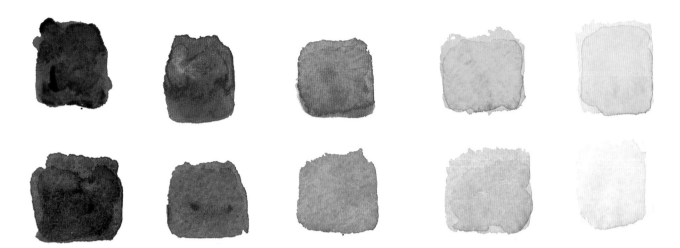

Color is easier to see than value is, but you must learn to think of both simultaneously. For that reason I like to use the word "color-value." To get a better grasp of this idea, try the exercises I've illustrated here. You might want to have a nine-value gray scale handy for reference.

I've chosen alizarin crimson and phthalo blue, strong dye colors that come out of the tube at a very dark value, so we won't need to add another color to darken them more. They'll hold their own even as we add water (in oil we'd be adding white to lighten value).

Starting at the left, make a block of alizarin about an inch square.

Make it as dark as you can, using almost no water. Is the paint soft on the palette? It had better be! Just to the right of the first one, make another block, this time adding a little more water. Make three more blocks, using a bit more water each time. You'll see the color begin to fade as you go lighter. Ideally, you should be hitting the values the first time with no second-wash corrections. You're aiming for a steady progression from dark to light.

You can correct the darker end with more pigment working wet-in-wet if you're skilled, but the lighter end, where you have no real color substance, is a killer. It would

be better to make a series of rows, say four, with no corrections. Let them all dry completely. Correcting wet or damp mid- to light values is very destructive.

When you've achieved a good value range with no big jumps between blocks, repeat the exercise using phthalo blue. Your job this time is to match the blue values to the red ones.

These exercises should show you how to 1) control the color-to-water ratio to achieve a specific value; 2) compare and match the values of two different colors; 3) develop patience and an affinity for the medium so you'll know when to correct and when not to.

CHANGING VALUE WITHIN COLOR FAMILIES

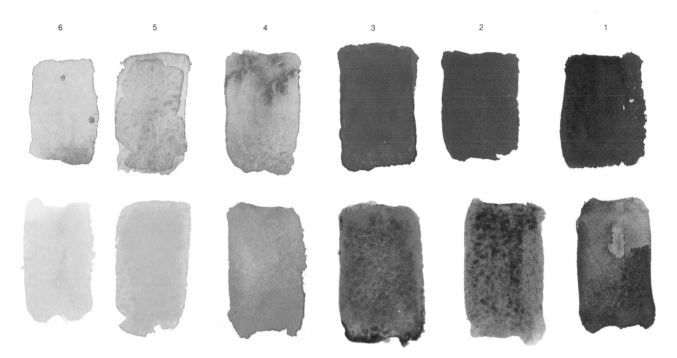

Many of the colors we work with come from the tube at mid-value, meaning that we have to figure a way to make them darker as well as lighter without tampering too much. The safest route is to lighten and darken within the same color family. Gaining this kind of control will help later when we start working with complements.

By family I mean ranges of colors that are contiguous in the spectrum—we can speak of a blue family, a red family, a yellow family.

Look at my chart. I've started from the center with the mid-values labeled #3: cadmium red, and raw sienna mixed with a touch of cad yellow. In the top row, moving leftward one block to #4,

note how cadmium red loses its strength and gets pasty and unpleasant as I add water. To give it pep, in the next block to the left (#5) I've added a touch of cad orange, which is the best way to get a warm light red. For a cool light red, use alizarin crimson with water, as in #6 (rose madder would be an alternative). Now look at the second block from the right (#2)—I've gone darker by adding alizarin to the cadmium red. The last block to the right (#1), my darkest red value, is pure alizarin.

Yellows are the hardest to control, since they're inherently light in value. Cadmium yellow (#4) is warm and the deepest yellow I use; cad yellow light (or

pale, #5) is lighter in value but still warm—I use it the most in flesh tones. The lightest of all is cadmium lemon (or Winsor yellow, #6), which is cool—too cool for skin tones but fine for mixing greens. When we try to darken yellows, we must resort to raw sienna—really a brown—and cadmium yellow (#3), a mixture that's opaque and a bit green, or raw sienna alone (#2). Finally we'd turn to a green (#1); this one is a mixture of cadmium yellow and ultramarine blue. Get into the habit of mixing your greens rather than resorting to Hooker's, which, although fine when you need green instantly, is a staining color that can't be lifted if you goof.

MIXING DARKS AND GRAYS

Whether I'm working in oil or in watercolor, I rarely use black to darken a value. I like black for its own sake. It can be a clean dark if your painting is too colorful and you need a foil. Manet used black to great advantage in his paintings, not as an additive but for contrast. I mix black only with dark earth colors or with dark greens and blues. The only time I use black with a light-valued color is when I mix it with a yellow or ochre to manage a green.

When you darken values, try to avoid mixing complements, because they can muddy a painting unless you're really skilled at using them. Keep your darks pure. Stay within a color family as best you can—but do experiment. In both oil and watercolor, for instance, you can get some really nice darks by combining alizarin crimson and phthalo blue.

Mixing complements gives you what we call grays. They *can* be great for very rich darks if you don't overdo it; think of these mixtures as dessert. In watercolor, I like the combination of alizarin crimson and Hooker's green dark, and in oil, alizarin crimson with viridian.

Avoid cadmium red as a mixer—it and some other reds can be too pasty. I use cad red only when I need to quiet a green, or when I'm painting flesh tones; otherwise, I use alizarin crimson as my mixing red.

The examples you see here are just a few of the possibilities. (In each oil swatch I've added a touch of white to show you a slightly lighter value.) Note that I've got cool and warm variations in my mixtures, something you should aim for as you experiment with different color combinations. Note, too, that nothing is homogenized: Darks and grays should have the life of the individual colors from which you mix them.

MIXING DARKS IN OIL

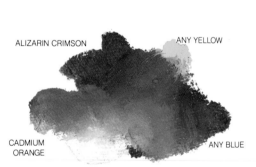

ALIZARIN CRIMSON
ANY YELLOW
CADMIUM ORANGE
ANY BLUE

RAW UMBER (IF YOU WANT COOL TONES)
BURNT UMBER (IF YOU WANT WARMTH)

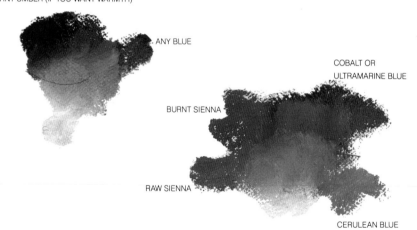

ANY BLUE

COBALT OR ULTRAMARINE BLUE
BURNT SIENNA
RAW SIENNA
CERULEAN BLUE

MIXING COMPLEMENTS IN OIL

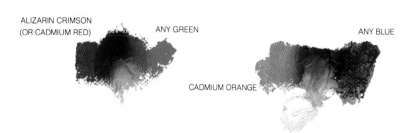

ALIZARIN CRIMSON
(OR CADMIUM RED)
ANY GREEN
CADMIUM ORANGE
ANY BLUE

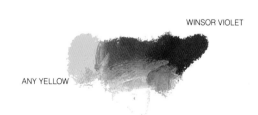

WINSOR VIOLET
ANY YELLOW

MIXING DARKS IN WATERCOLOR

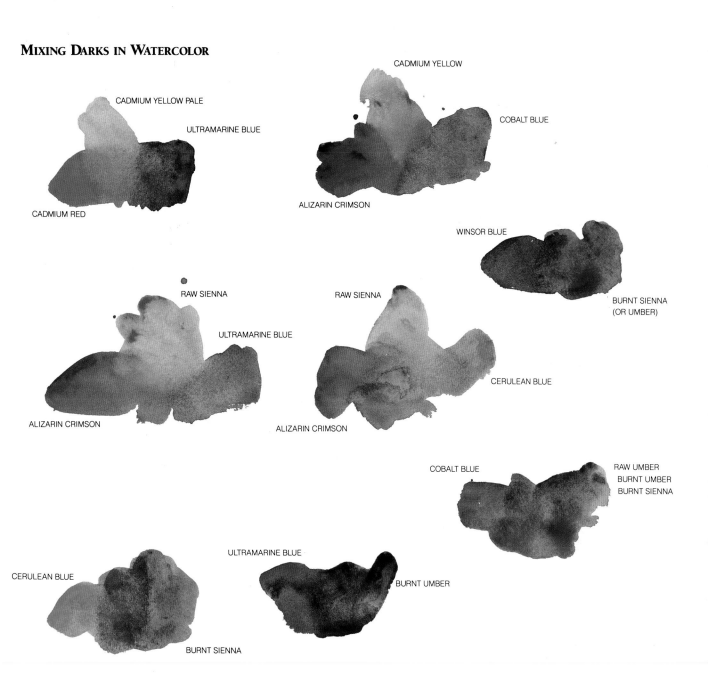

CADMIUM YELLOW PALE

ULTRAMARINE BLUE

CADMIUM RED

CADMIUM YELLOW

COBALT BLUE

ALIZARIN CRIMSON

WINSOR BLUE

BURNT SIENNA
(OR UMBER)

RAW SIENNA

ULTRAMARINE BLUE

ALIZARIN CRIMSON

RAW SIENNA

CERULEAN BLUE

ALIZARIN CRIMSON

COBALT BLUE

RAW UMBER
BURNT UMBER
BURNT SIENNA

ULTRAMARINE BLUE

BURNT UMBER

CERULEAN BLUE

BURNT SIENNA

MIXING COMPLEMENTS IN WATERCOLOR

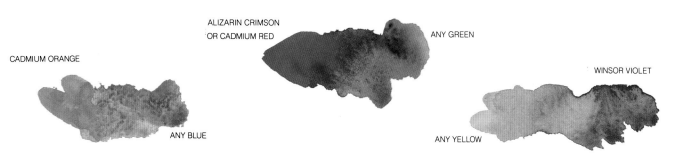

CADMIUM ORANGE

ANY BLUE

ALIZARIN CRIMSON
OR CADMIUM RED

ANY GREEN

WINSOR VIOLET

ANY YELLOW

43

MIXING SKIN TONES

Everyone wants to know how to paint the color of skin. No matter what the ethnic group, all skin tones are composed of a red, a yellow, and a complement—blue, purple, or green. Unfortunately, skin often looks like no color at all. It's brown or tan with no hints of anything else. Actually, value is more important in painting skin than color is. I have a poster of a Degas painting of a ballet class in which the dancers are shown mainly in shadow with hints of rim lighting. The values carry the painting. The colors Degas uses in the skin are often just the same as colors found in the floor, walls, and clothing; in fact, skin and clothing often merge.

Let's try a simple mixture. I'm reminded of cooking and making a basic white sauce of butter, flour, and milk. It isn't very exciting but it's serviceable. The same is true of the swatches you see here.

For my red I've used Winsor & Newton cadmium red; if you're painting with any other brand, use cadmium red light. For your yellow use cadmium yellow light or cad yellow pale; stay away from cold yellows like lemon. This red-yellow combination will make a passable light-valued flesh tone; blue is necessary to make it really good, but right now adding blue complicates matters.

Start with fresh paint. Squeeze a bit of red and yellow into their proper places on your palette. Rinse your brush in clean water and give it one firm shake of the wrist, as if you were making a stroke with a tennis racquet or casting a line with a fly rod. Pick up some red and apply it to the paper. Make sure it's not too watery. Rinse the brush again, shake it, and do the same with the yellow, placing it right up against the damp red. Don't mix the two together; allow them to mix on their own as they dry. You should have controlled bleeding. Your swatches should look like mine. Below, note the center portion, where I've outlined a square to show you the color you're after.

Now try painting a basic flesh-tone shadow. Follow the same procedure as above, but use raw sienna instead of cadmium yellow. If you use too much water, you won't get a dark enough value.

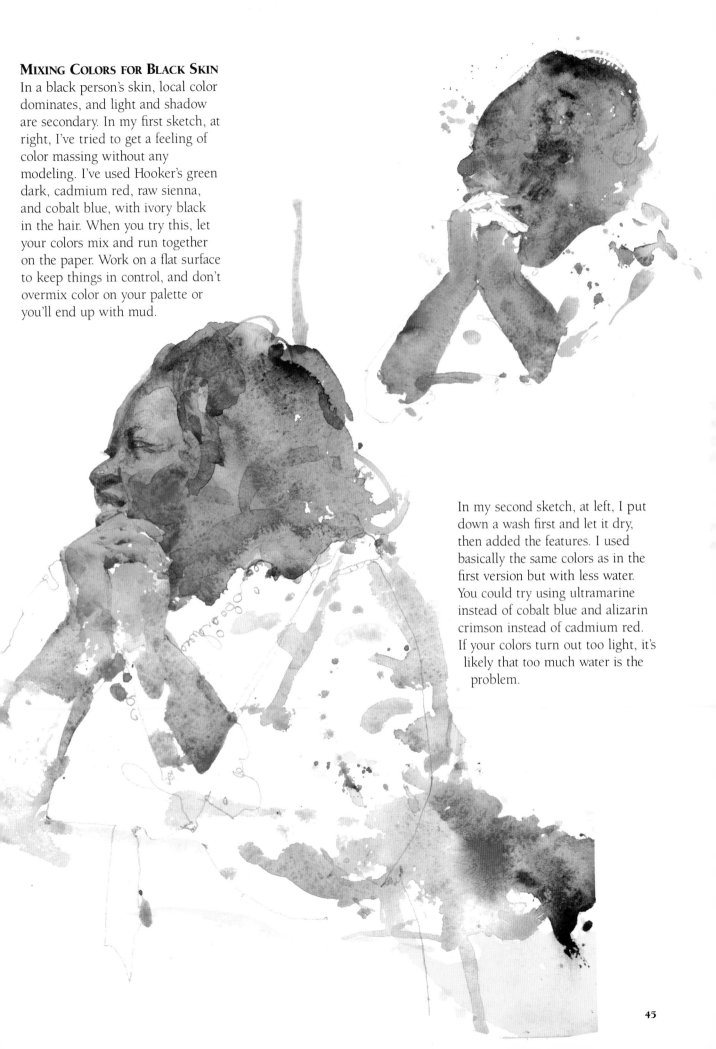

MIXING COLORS FOR BLACK SKIN

In a black person's skin, local color dominates, and light and shadow are secondary. In my first sketch, at right, I've tried to get a feeling of color massing without any modeling. I've used Hooker's green dark, cadmium red, raw sienna, and cobalt blue, with ivory black in the hair. When you try this, let your colors mix and run together on the paper. Work on a flat surface to keep things in control, and don't overmix color on your palette or you'll end up with mud.

In my second sketch, at left, I put down a wash first and let it dry, then added the features. I used basically the same colors as in the first version but with less water. You could try using ultramarine instead of cobalt blue and alizarin crimson instead of cadmium red. If your colors turn out too light, it's likely that too much water is the problem.

WORKING WITH VALUE AND COLOR

To show you how to handle value and color in an actual painting situation, I've chosen my house as a subject. Note how in my contour drawing the house and trees form a continuous shape, the elements merging and losing their separate identities. I've set up an abstract pattern.

Now we'll do a two-value sketch. Make a silhouette drawing of the house and trees on watercolor paper (I've used ballpoint pen). At the bottom margin, make a six-value scale with ivory black and water, using the white of the paper for your lightest value. Paint the silhouette, weaving the darks together in a connected shape. Concentrate on the proportions of the house and the sizes of the light and dark shapes. Forget about color. Assuming there's strong sunlight illuminating our subject, the dark silhouette should be about the same value as the middle two blocks on your value scale—a difference of at least three values between light and shadow. That's a pretty strong contrast.

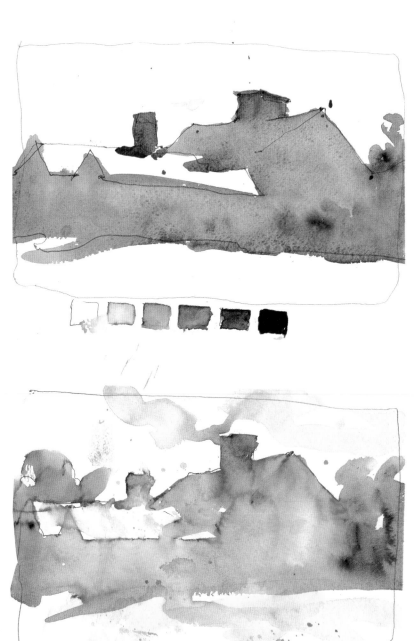

This second example shows what happens when the light on our subject is more diffuse—say in foggy or misty conditions. Strong, simple light-and-dark contrasts, and therefore shapes, disappear. We see lights in what should be shadows and somber tones in what should be clean and light, causing clutter. Still, the house remains recognizable here. When you paint under difficult or changeable lighting conditions, the main thing is not to lose the idea. If you begin with a strong light and the sun quits on you, either start a new painting or stick with your original pattern of darks and lights, keeping contrasts simple.

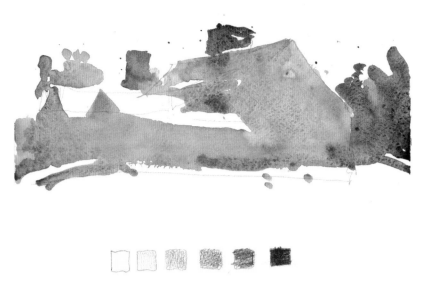

In this sketch I've used the same colors you'll find in the finished painting (next page). The main part of the house is a combination of alizarin crimson, cerulean blue, cobalt blue, and ultramarine blue; I used burnt umber in the chimney at right and cadmium red and Hooker's green dark in the one at left. In reality I saw a slate-gray house, but as I began painting I concentrated on suggestions of warm and cool tones within the gray, then thought about the colors that make grays. I forgot about the house as a house and saw it instead as a defined area to be filled in with color at the correct value.

The top row of color blocks shows blended, homogenized mixtures of the hues you might see in a gray house with a brown chimney framed by green trees. In the second row I've used exactly the same colors, but without blending the pigments together first. Wouldn't you say the lower row is more vibrant? Try this exercise yourself. Using the same colors for both rows, starting at left, make a cool gray using alizarin crimson, cerulean blue, and raw sienna; then in the middle, a warm gray composed of Hooker's green dark and cadmium red; and at right, a green composed of cobalt blue and cadmium lemon. For the top row, mix the colors on the palette first, then fill in the blocks. For the second row, let the various pigments for each of the three combinations mix right on the paper. You might have to wet the blocks first, then drop the colors in wet-in-wet; the trick is to get just the right pigment-to-water ratio.

KIRIN LITE

Watercolor on Fabriano rough paper, 22 × 30″ (55.9 × 76.2 cm), courtesy of Munson Gallery.

In the finished painting I've managed good value contrast in which dark, light, and mid-values fit together like pieces of a puzzle, forming a pleasing pattern. But uppermost in many a person's mind is the question, "What colors are you using?" I've heard this inquiry so often, and it's based on the assumption that if I use the "right" colors the picture will be good. Unfortunately, this just isn't true. What matters most is, first of all, your ability to see value relationships, and second, the way you mix whatever colors you choose. Color selection itself comes third. The challenge for me in this case was to translate a gray house into pieces of value and color; with grays and neutral areas, we tend to see only tones.

ASSIGNMENT

Make several value sketches of the same subject. Begin by following the example of my house. Do a value scale along the bottom margin. Choose a value and try to match it as you paint the house. Try not to correct. Instead, go on to a second and third sketch, experimenting with different paint-to-water ratios. At first your colors might look washed out—remember, a color that looks rich and brilliant when wet often looks pallid upon drying. Don't fuss; just go on to another sketch and make it better. Always think of the subject you're about to paint as an area of color and value. If you can manage a silhouette of my house with good color variations and a clean value contrast with the white paper, you're on the trail.

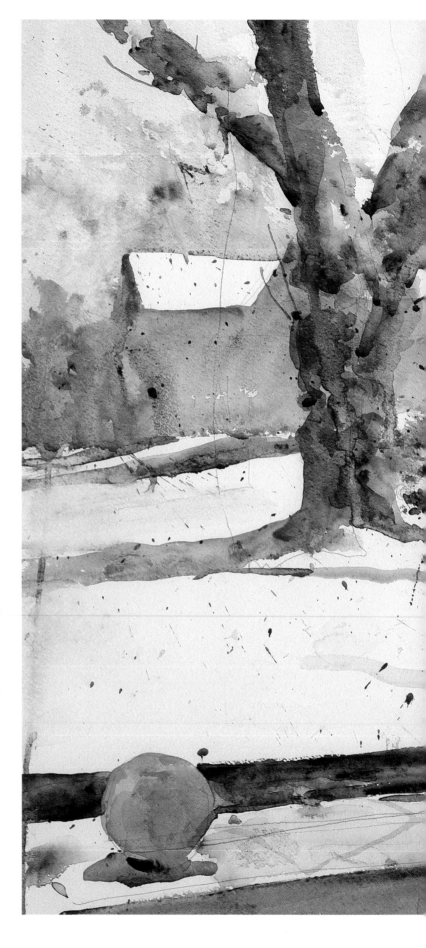

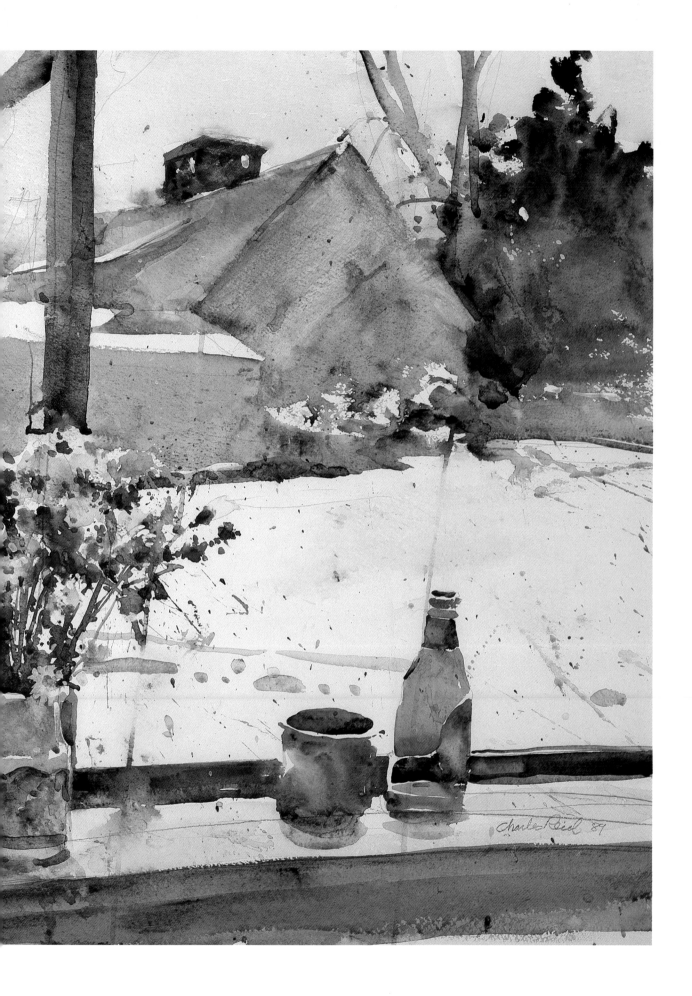

USING A LIMITED PALETTE

As I've said, many students think success in painting is dependent on the colors they use. I don't believe this is true. A good painting can be done with just six colors. Take a look at these little watercolor sketches I did on a salmon-fishing trip. I painted them in a 5 × 7″ sketchbook using a palette of only six hues, yet each picture has a unique mood expressing a different time of day.

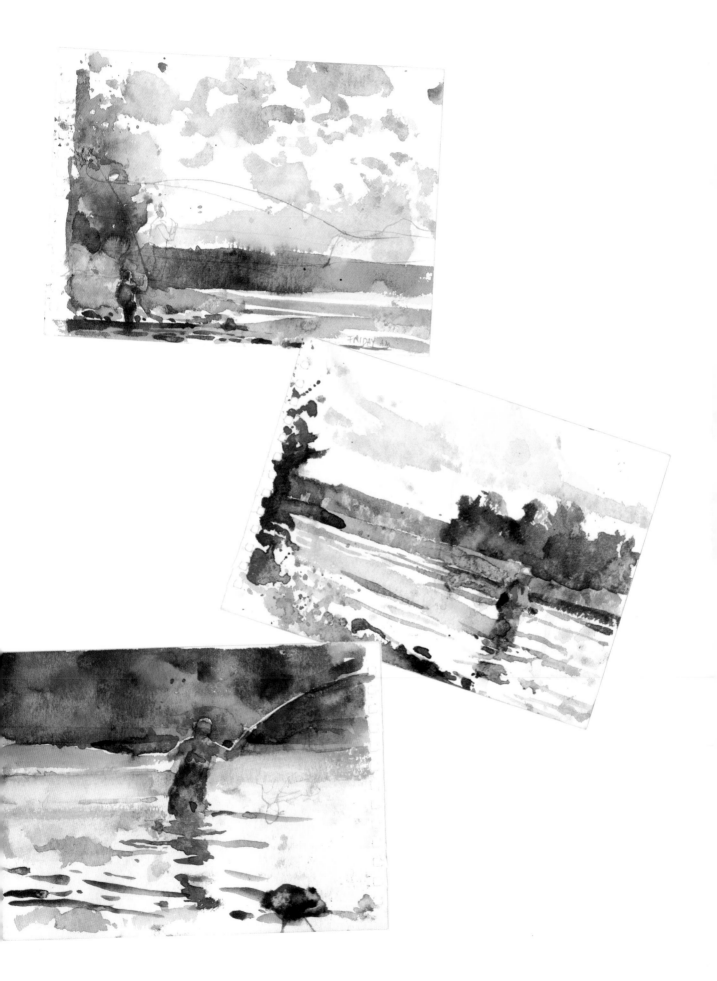

In a recent class I learned that half the students hadn't painted in six months. But if you have fifteen minutes a day to spare, you can easily get some practice in. All you need is a simple kit consisting of a small palette, a decent little round brush (about ¾″ size) that will point, a small sketchbook (5 × 7″ is good), and six colors: alizarin crimson, cadmium red, cadmium lemon, raw sienna, Winsor (or phthalo) green, and ultramarine (or phthalo) blue. Limiting yourself to just a few items will make it easy to learn how these six colors work together. Don't worry about making pictures; I want you just to make swatches. Using these colors, you should be able to mix light, middle, and dark values. You should be able to reach a value without overwashes and corrections. You should learn to see color mixing on its own without your interference. Let the pigment and water do the work.

First, try some basic mixtures:

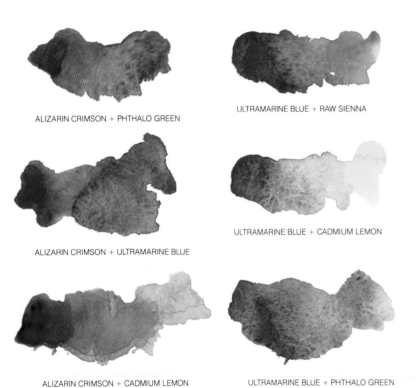

ALIZARIN CRIMSON + PHTHALO GREEN

ULTRAMARINE BLUE + RAW SIENNA

ALIZARIN CRIMSON + ULTRAMARINE BLUE

ULTRAMARINE BLUE + CADMIUM LEMON

ALIZARIN CRIMSON + CADMIUM LEMON

ULTRAMARINE BLUE + PHTHALO GREEN

Now make darker values, using less water and more pigment. Do you see that you can get as dark as you'd possibly want to go and still have color?

ALIZARIN CRIMSON + ULTRAMARINE BLUE

ALIZARIN CRIMSON + PHTHALO GREEN

Here are some combinations that are still dark but have a bit of variety. They would be good for dark mid-values.

ALIZARIN CRIMSON + PHTHALO GREEN + A TOUCH OF RAW SIENNA

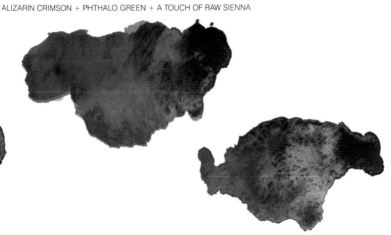

ALIZARIN CRIMSON + ULTRAMARINE BLUE + A TOUCH OF RAW SIENNA

CADMIUM RED + PHTHALO GREEN + A TOUCH OF RAW SIENNA

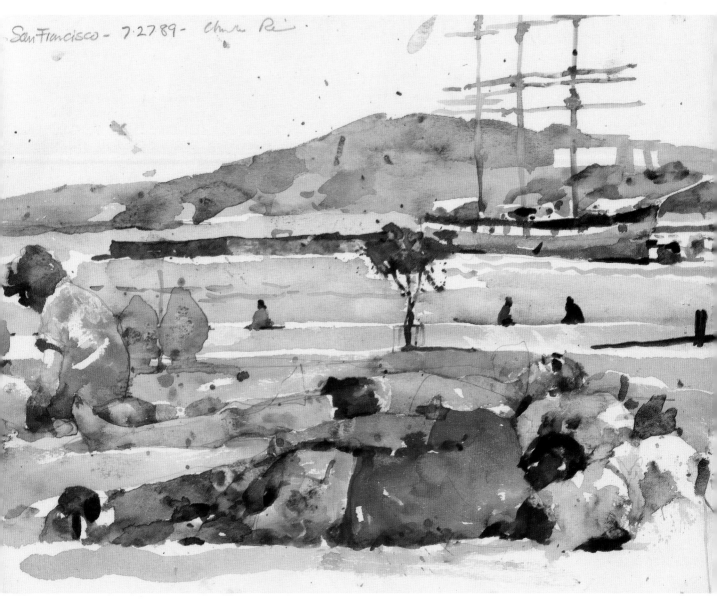

San Francisco - 7·27·89 - *Chris Re*

SAN FRANCISCO PARK
Watercolor on cold-pressed paper,
10 × 14″ (25.4 × 35.6 cm).

Here I've worked up to a larger sketchbook but have kept my colors still to just "the six." Working bigger doesn't mean you need to expand your palette. So let's go beyond color. I'd like you to think about the negative shapes that bring the man's torso and ankles into focus. Think about getting *value*—the simple darks in the hair, shorts, and trousers, the uncluttered light and mid-values.

This sketch took an hour and forty-five minutes. Each bit of the figures, each bit of the grass, water, distant hills, and ship, was considered. I tested values and colors on my palette to arrive at the *mot juste*—just the right value and color without a lot of fussing about. You can do this only if your color and value "vocabulary" is settled in your mind before you start painting.

COLOR AND VALUE IN DESIGN

It's important to learn to see subjects abstractly, because only then can we perceive the crucial roles color and value play in good design. In painting terms, *value* means how dark or light a shape appears on paper or canvas. *Local color* refers to the actual color of an object (a red apple, a blue shirt). But because our brains tend to edit in translating our eyes' message, we identify an object and its details in terms of how it is affected by light and shadow, and often miss its inherent qualities—its actual color and value.

These Polaroid photos of my daughter, Sarah, and wife, Judith, help explain local color—although maybe "inherent value" is a more accurate term. These pictures were taken with a flash, which flattens and therefore simplifies images by eliminating a lot of the confusing small forms you'd see in nature. Turn the book upside down to look at the photos and you'll see abstractions. The people aren't as important as the arrangement of dark and light shapes.

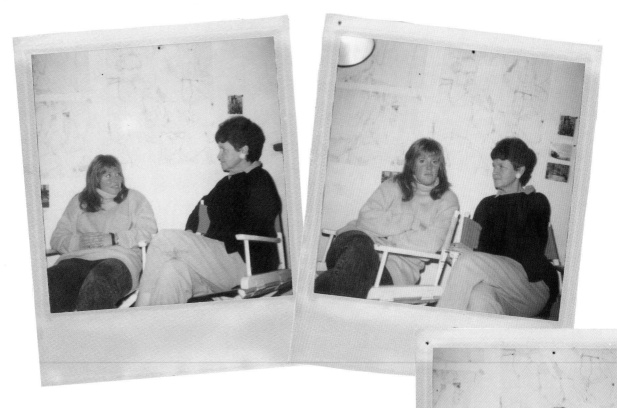

In the two photographs above, the dark shapes seem scattered. The problem isn't in figure placement but in the placement and relationships of the dark and light values in the models and in the negative darks and lights in the background. In the photograph at right, however, the dark shapes seem cohesive and integrated. Now have a look at my "correction" sketches on the page opposite.

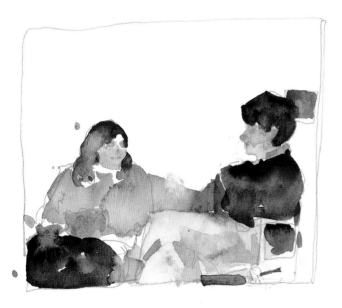

In the photo at far left on page 54, the darks form separate groupings that divide the picture in two. In my sketch, I've created a bridge with an imaginary cast shadow. Judy's dark shirt lightens a bit and merges with the cast shadow. Softening her arm helps me connect my darks but also keeps the arm from popping forward, as dark against light always tends to do. Moving the postcard behind Judy's head connects her to the picture border. Just as a guide, try to have 75 percent of your darks connected. In this sketch, they're what grab our eye and keep it flowing through the picture.

When I compose a subject I modify values, lightening darks and darkening lights to make connections and better relationships. In this second sketch, notice how Judith's sweater merges with her trousers at right; I merely let the color lighten as I worked downward. I've also used some optically strong colors, such as intense blue and pure Indian yellow, which can have as much weight as strong values. A dark value stops the eye, while a strong color attracts the eye without stopping it. I used cadmium red for the left side of Judy's chair, letting it mix with the complementary Hooker's green of her sweater to create a brownish mid-value, while to the right I used pure cad red as an optically strong counterpoint.

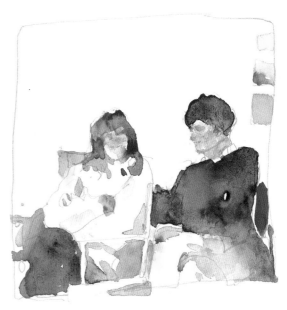

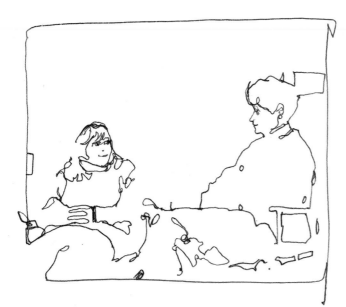

ASSIGNMENT

Using the Polaroids, make some 6 × 8″ local value studies of the shapes you see in them. Start with a contour drawing. Think about where you want the darks to flow from the background negatives, into and through the figures. Avoid any boundaries that block the flow. In my contour sketch, note the negative chair shape, and how the line flows between the figures—I don't complete one and then go on to the other. When you start to paint, don't impose light and shadow; if a shadow on a light-value shirt competes with a dark local color, you're on the wrong track.

PUTTING COLOR TO WORK IN DESIGN

Forgetting about color for the moment, I've done a rough pencil sketch of my composition. The lobster seems too centered and isolated; it just looks like a dark stuck in the middle of the composition. Now look at the painting.

Here I've stressed color: The lobster was painted with reds right out of the tube, but I've used a middle value, not one that's too dark. I've applied pure color in other areas too—in the lemons and the apple. But the colors don't seem garish, because I cut the intensity by using complements in several places—purple flowers adjacent to the lemon at center, a green pepper next to my red apple, and so on. There are definite grays as well, both warm and cool—the shading on the lobster's right claw, some of the cast shadows, the bit of wall you see in the background. In a color-oriented painting such as this, the placement of objects isn't as critical as it is in value-oriented paintings. Whereas in my pencil sketch the lobster "read" as too dark a shape to work well in an overall design, in the painting, even though the lobster is still the dominant shape, its red color is a middle value that doesn't overpower the composition but is echoed elsewhere and offset by other colors to form a pleasing pattern.

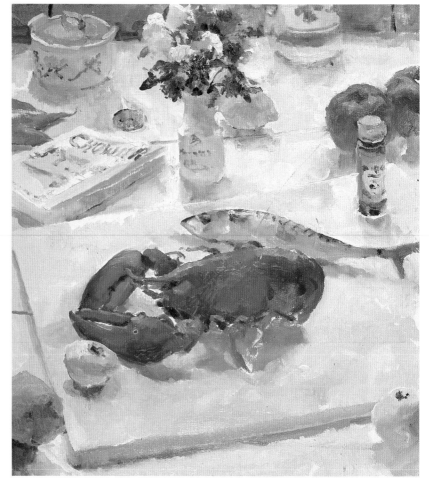

LOBSTER AND MACKEREL
Oil on canvas, 20 × 20″ (50.8 × 50.8 cm).

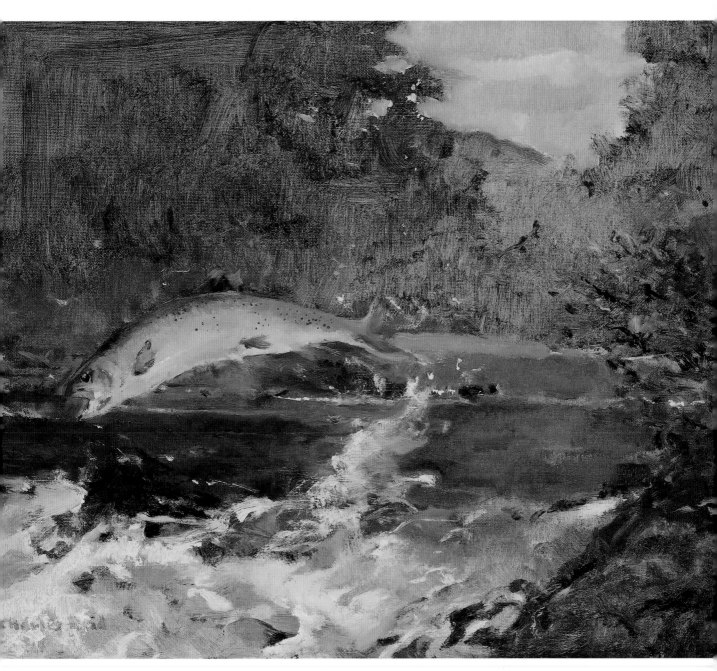

CUTTHROAT TROUT
Oil on canvas, 18 × 24"
(45.7 × 61.0 cm), courtesy of
Sports Afield.

I used just a spot of red for the fisherman (toward the right in the middle ground) and a speck on the left of the composition as relief from the fish, but these touches also reflect the spots of red in the trout's jaw and fin and help keep the viewer's eye from getting stuck in any one area for too long. The water splash in the foreground helps direct your attention off to the right toward the fisherman. When you have a center of interest that's as obvious as my trout, introduce shapes, colors, and values as diversions that will make the eye move throughout the rest of the painting.

COMPOSING WITH COLOR AND VALUE

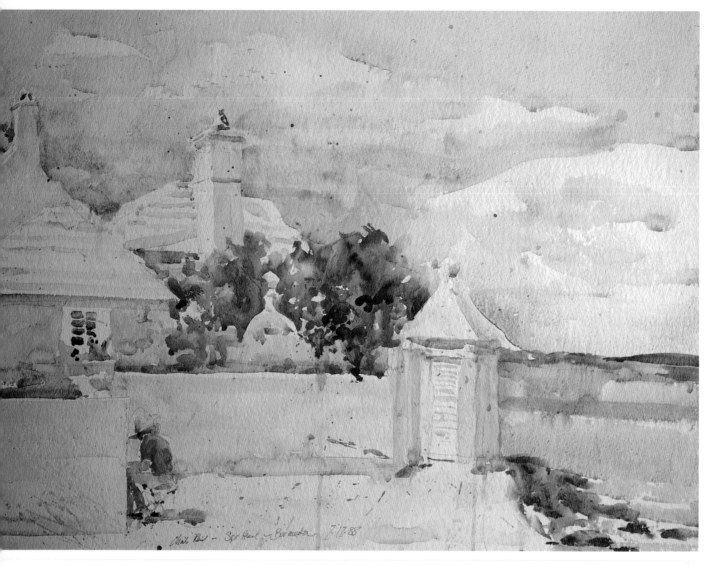

SPITHEAD, BERMUDA
Watercolor on Fabriano 140-lb. rough paper, 12 × 18" (30.5 × 45.7 cm), collection of Jeanette Snyder.

The big elements in this painting are the dark trees at the center and the rocks at right. Although these areas have some color strength—the rocks get a boost from cadmium orange and raw sienna—it's their value that dominates; they form definite darks. The water on the horizon has both significant color and value, while the figure in the red shirt relies mainly on color. Yet as small as the figure is in the overall composition, she holds her own. This painting illustrates my point that a strong color can be as vital as a strong value. Here it's interesting that the buildings, so important as objects, play such a small part in the painting's abstract foundation.

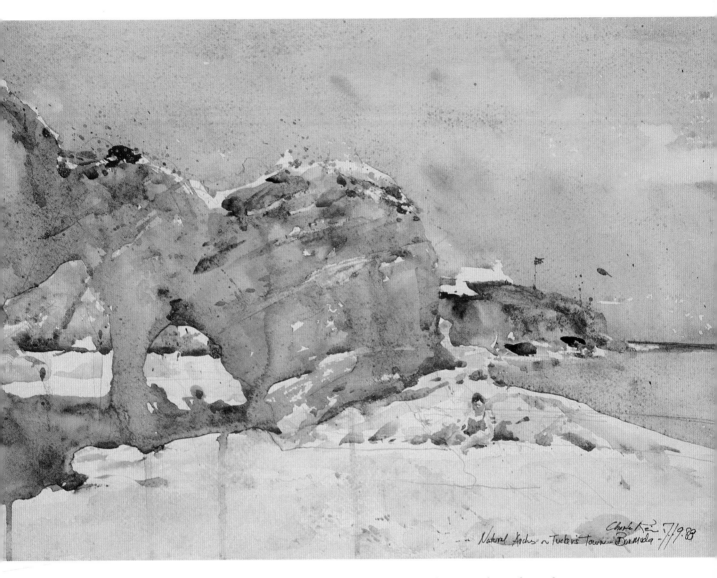

NATURAL ARCHES, BERMUDA
Watercolor on Fabriano 140-lb. rough paper, 14 × 18″ (35.6 × 45.7 cm), collection of Judith Reid.

Color and value relationships are the same throughout this picture; squint at it and you'll see what I mean. I made the arches big in relation to the figures so you know they're in the foreground. Instead of separating the painting into picture planes, I wanted the viewer's eye to see the arches, distant headland, sky, and water as one interwoven shape that clearly contrasts with the sand, distant house, and sunstruck parts of the arches. Essentially it's a two-value painting composed of two large, interconnected shapes.

Part Three
LIGHT & SHADOW

Learning to handle light and shadow in painting is crucial. You have to look at shadows as abstract shapes that are integral with your subject, not merely adjuncts that you put in to create the illusion of depth. Shadows are pieces of the design puzzle—they can be as important as the objects or figures themselves. I explained in the chapter on drawing that there are two kinds of shadows—those that form on the sides of objects that are turned away from a direct light source, and those that are cast by objects located in the path of strong direct light. Capturing all of this in painting can be tricky, especially because you don't always have complete control over lighting conditions. What's most important is that you become able to "read" the shadows in the subject before you and translate them into design components that suit the needs of your painting.

SHADOWS, DEPTH, AND DESIGN

Compare the still life watercolor sketch at left with the oil painting of the same subject, below. In the watercolor, I've left out the cast shadows. Note how isolated the objects look, and how flat and bereft of life the picture seems. In the finished painting the shadows and cast shadows are definite compositional forms and are as significant as the objects themselves. If you squint at the painting you'll see double images. Think of objects and cast shadows as single, combined shapes.

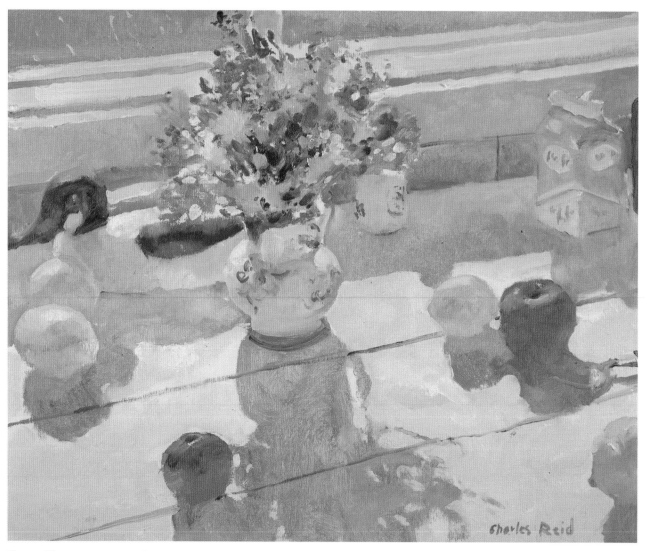

FIELD FLOWERS WITH APPLES
Oil on plywood panel, 18 × 22" (45.7 × 55.9 cm), courtesy of Munson Gallery.

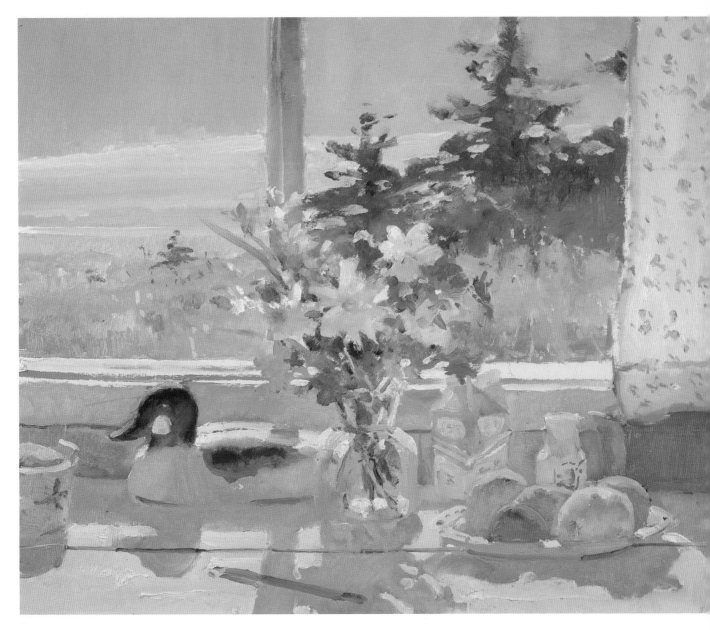

JUDITH'S GOLDEN EYE

Oil on plywood panel, 18 × 22"
(45.7 × 55.9 cm), courtesy of Munson
Gallery.

I think it's easy to see the shadows
and cast shadows as unified shapes
in this painting. My subject was
lit from behind and above, so
shadows form on the front of the
objects and merge with the cast
shadows. Starting from the left,
note how the shadow that begins
under the soufflé dish forms a
continuum with the shadow of the
window frame, the decoy, the vase,

the dish of fruit, and the red
casserole at right. In spite of the
fact that shadows can suggest
depth, here I'm not really trying to
do that—I'm concerned with
abstract pattern.

Have you heard the rule that
using warmer colors and darker
values in the foreground and cooler
colors and lighter values in the
distance can suggest depth in a
painting? There's truth in this, but
usually distinctions between
picture planes—foreground,
middle ground, and distant

background—don't concern me.

In *Judith's Golden Eye*, distant
and closer darks are equal in value.
Darks are used to weave the
background and foreground
together as if they were on the
same picture plane. You'll see the
trees melding into the flower darks
and on to the accents of the decoy.
Bright color—the reds in the
tomato and the casserole dish—
does bring the table forward, but I
wasn't really interested in creating
perspective with it; I was after a
strong two-dimensional design.

SEEING SHADOW SHAPES IN STRONG LIGHT

Students have a hard time seeing light and dark shapes, even under a strong single light. When rendering a face that's brightly illuminated, for example, you might draw in eyelids, even though you can't really see them. You'd actually see just dark ovals under the brows.

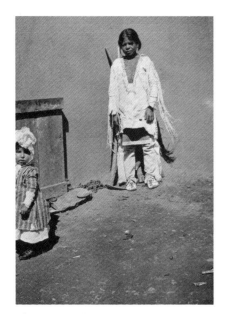

This 1905 photograph by B. G. Randall shows what we see looking at people under a strong light. The problem is that most students paint from their knowledge of the symbols that make up a face: eyelids, nostrils, and lips. Here, for instance, we can't see the lower lip of either child; rather, we see the shadow formed by the upper lip and the shadow *under* the lower lip. It's hard to leave out what we know is there even if we can't see it. But all that's really visible are shapes of light and dark. Thus, in my drawing, I've blocked in just shadows and cast shadow shapes for the whole composition.

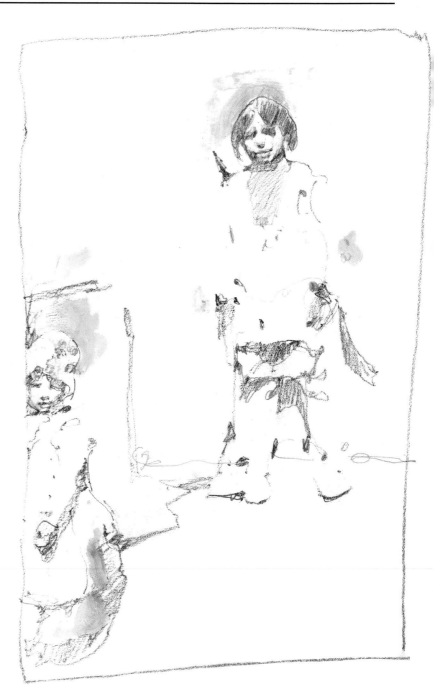

ASSIGNMENT

Follow the example of my drawing. Copy just the dark shapes you see in the photograph. Sometimes it will be hard to decide what's what. On the first try, put in only the darkest darks. Make sure you draw whole shapes, even if they cross over physical boundaries. For instance, a shadow might encompass a face and part of a shirt, but you wouldn't show a boundary between the two within the shadow shape.

AVOIDING CONFUSION IN SHADOWS

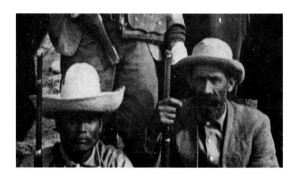

Both of the heads in this photo have about the same light-and-shadow pattern. Hoping it will help you look more closely at the problem, I've reversed the two men in my sketch. The configuration of light and shadow in the face of the man on the left is organized and readable. His friend, however, is less fortunate. I've exaggerated the shadow fragmentation in a way that's typical of the amount of confusion I see in class.

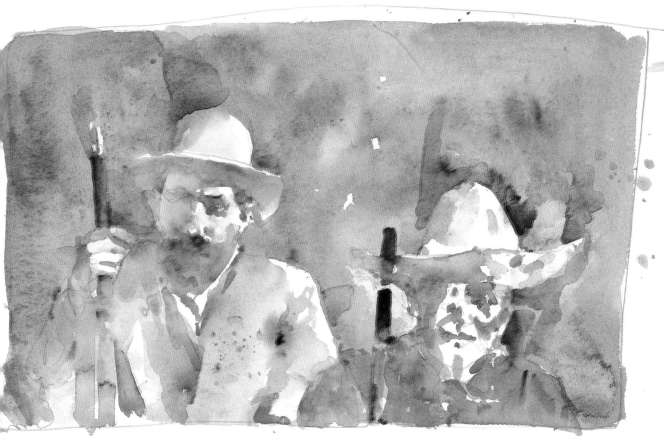

ASSIGNMENT

Using the photo and my figure on the left as a guide, make a correction painting of the fragmented head. Use just two values in the flesh tones, one for light and one for shadow. Make sure you end up with two large, connected shapes in which all the values in shadow look like shadow and all the values out in the light look light.

SCULPTING WITH SHADOWS

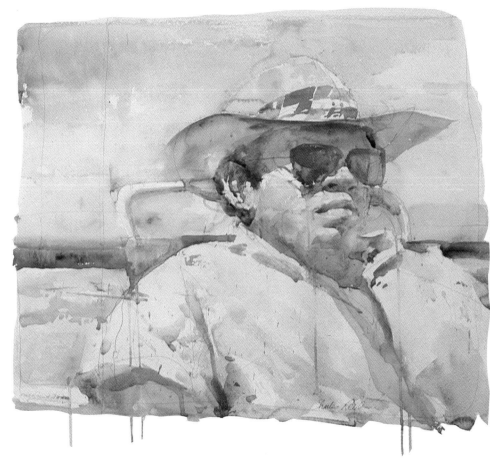

SHADES
Watercolor, 15 × 15"
(38.1 × 38.1 cm).

I've already touched on making two-value drawings and color sketches, but I'd like to backtrack a bit. It's hard to make a good painting with two values. So for now, don't think about good painting; instead, think about making a good foundation for a good painting.

When I was in art school, we'd start by making a simplified value study in the upper corner of a proposed painting. The idea was to pare a complicated and awesome task down to the absolute essentials. The small value study was meant as a guide and an inspiration for simplicity. Although I've never made sketches as

blueprints for a final painting, they're what I do to warm up, get prepared; they help me understand the terrain.

I recommend that you try the class assignment I've illustrated here. The point of this lesson is to understand how to make darks describe the bulk and character of the figure's head—how to sculpt a face using shadows. I began with a picture boundary of 15 × 15" on a full sheet of watercolor paper measuring 22 × 30". I made a very small facsimile of my boundary in the upper corner and did a very simple contour drawing of my subject's head, which I then turned into a two-value study. You

could use a diluted black or umber for your face, hat, and sunglasses; color doesn't matter at this point. It's the ability to define and control a dark shape that's absolutely critical: This is what is at the core of classical painting.

Scale is really important. What looks good small becomes difficult as you work bigger, especially in watercolor, because it's hard to control value with larger washes. To learn to mold the shadows on a face correctly, work small but accurately.

In my finished painting I went on to make a composition by inventing a seascape in the background.

LIGHT, SHADOW, AND LOCAL COLOR

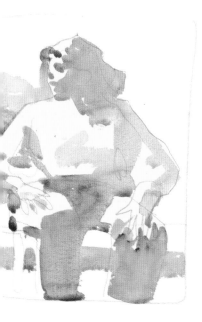

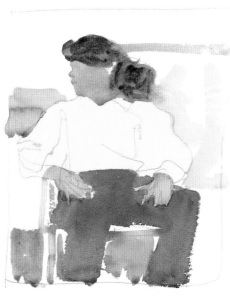

The sketch at far left shows only the light and shadows on my subject. The values you see in shadowed areas should be compatible with one another, because shadow has a way of obscuring variety. Shadow affects objects the way twilight makes it hard to see details and gradations. The same holds true for bright light; a strong light can "wash out" value distinctions and make everything under its influence look equal in value.

The second sketch shows only flat, local color—blue pants, brown hair, and so on. But try not to think of color; look at the differences between the *inherent values* of the skin, hair, shirt, and trousers. Do you see that the blue is about equal in value to the brown hair, yet is much darker than the skin, which is darker than the shirt?

The final sketch shows what happens when we combine light, shadow, and local color. (Imagine projecting a slide of my first sketch over the second one.) You'll see that the bright light affects the color and value of the subject but doesn't obliterate either quality, and that even in shadowed areas there are some visible gradations of value.

I mean to stress that this is a simplification of a complicated artistic problem. There are no snug harbors in painting. This is a classical solution to handling light, shadow, and color, something you'll find in works by Degas, Velázquez, and Vermeer. Painters like Gauguin, Bonnard, Vuillard, and Matisse, however, gave shape and local color predominance in their work and were little concerned with the illusionistic effects of light and shadow.

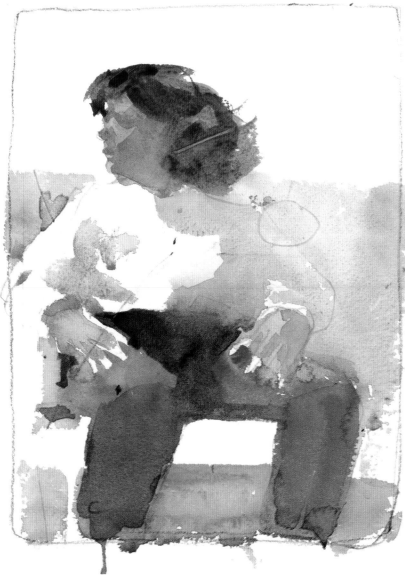

COMPOSING WITH BACKLIT SHAPES

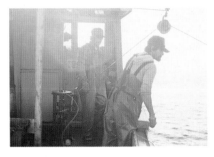

The photograph above was taken off the southwest coast of Nova Scotia during the last week in November. The weather was quite unusual for that time of year; there should have been chop, maybe sleet, but not fog and shirt-sleeve temperatures. The fog shrouds the men. They seem immersed in silence. The photo gives me the chance to show that shooting into the light, without a flash, can help simplify and change a cluttered fishing boat interior into a big shape. If you were actually on the scene and trying to paint it, you'd probably pick up on all the detail in the cabin—and end up with a cluttered painting. What you can't see, you can't paint.

Before you begin to paint, first get the "big idea": If possible, break your composition into two big shapes. It's easier to do this if you're following a backlit photo. If the design looks good with only two shapes, you've probably got a good composition and are on track. Squint at my first sketch (top) and I think you'll see two major shapes—a dark silhouette against the light background— with somewhat lighter values evident in the figure at right, who's standing out in the light, where some gradations become visible.

In my second sketch (bottom) I gave the foreground figure a better gesture than in the first. Is the painting better overall? Yes, if you're talking about this figure, but if the atmosphere of the boat is the point, the first sketch is just as good. Your main goal is to set up a good picture structure with two major values. Then you can make changes to tell the story, as I did in my second sketch—as long as you keep the integrity of the "big idea," the picture structure.

Backlighting turns objects and figures into silhouettes, making it easy to see and thus compose with strong, simple shapes.

To gain practice, set some objects against a window and make a basic two-value sketch, painting definite dark shapes against a light background. Your sketch should be the remembered impression—as if you'd had only a second to record the scene in your mind and then had to paint it from memory. In my sketch, notice that objects merge into one another. Where the chair and curtain overlap, for example, they form a single dark shape and cease to be distinct entities. Separations between shapes are determined by light, not by the physical identities of the objects the shapes represent.

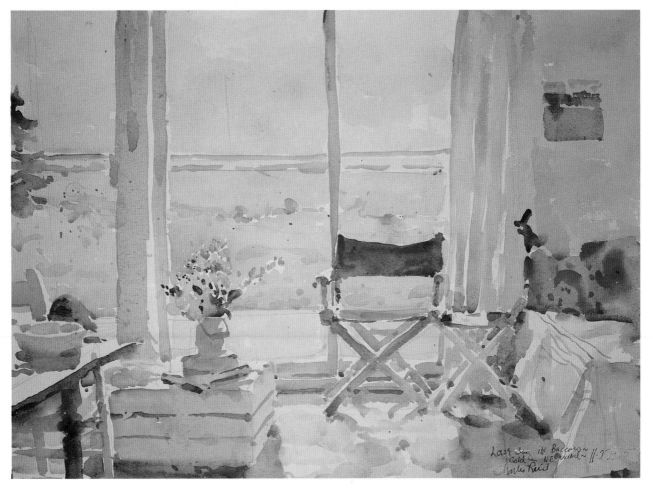

LAST DAY
Watercolor, 15 × 20"
(38.1 × 50.8 cm),
courtesy of Munson
Gallery.

My finished painting looks a lot different from the sketch. The sketch is reality; the painting is my interpretation of reality. I've made many changes—for instance, I chose to lighten values inside the room with sunlight. Before you're ready to take interpretative control of your subject, you have to understand what's really there.

I love to paint ships. I did these after teaching a class up on a desolate hill where the sun beat down without mercy. While Judith found comfort in the shower, I painted.

The sketch on the right-hand page is a facsimile of the first wash I put down for the finished painting, which consisted of cobalt and cerulean blue, alizarin crimson, and yellow ochre. I drew in the silhouette, defining both ships plus the shore as a single shape. I mixed the paint a bit on the palette, but also on the paper (you can see traces of individual colors).

I did the finished painting in two stages. My sketch represents the first stage; I let the wash dry completely, then added the shadow shapes. You can't do a two-value painting unless there are shadow shapes you can see easily; you need sunlight for this kind of definition. Just above the letter D on the hull, you'll see a definite shape where the ship's superstructure begins—that's where I started my shadow shape. Always paint your shadow shapes at the point where light meets shadow. Paint from light's boundary into shadow; never begin within shadow and paint toward the light.

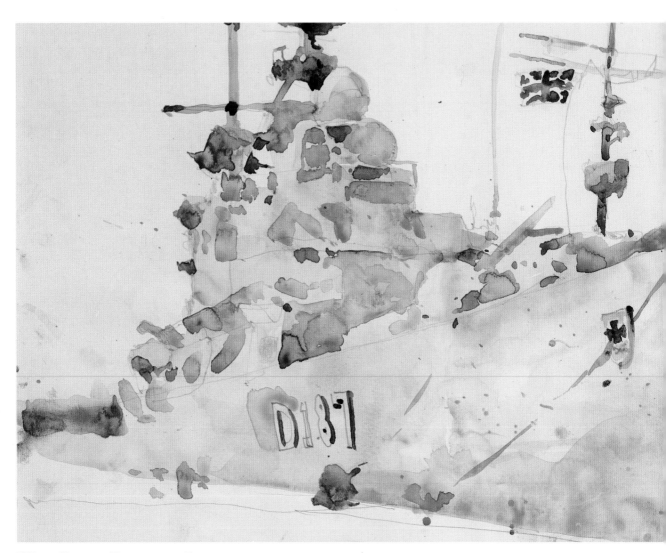

WEST GERMAN DESTROYER, BARBADOS
Watercolor on Fabriano cold-pressed paper, 7 × 20″ (17.8 × 50.8 cm).

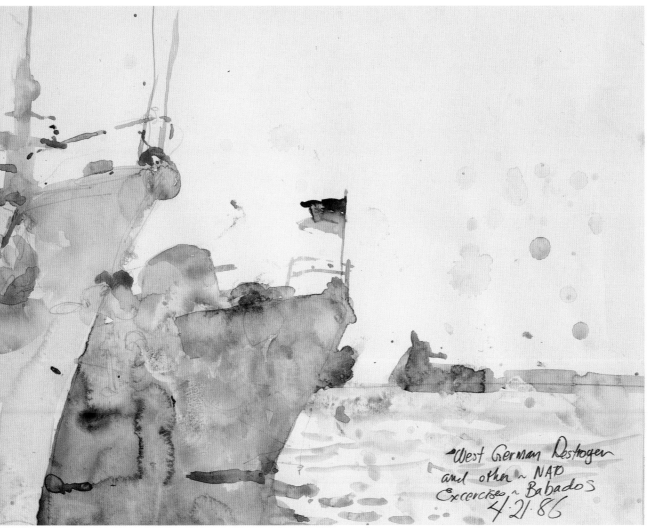

West German Destroyer
and other NATO
Excercises ~ Babados
4·21·86

LIGHT AND SHADOW IN LANDSCAPES

Students often find their snow scenes more successful than other landscape efforts. Of course, it's because they're forced to paint simple light and dark shapes. It's natural to focus on details and miss the overall value difference between two adjoining areas. But a snow scene forces us to see the differences. It's the same with fog and any scene that's backlit. They help us simplify and see shapes rather than details.

Backlighting distills subjects to their essential silhouettes. There's no apparent modeling to distract us. Value stays pretty constant within the silhouettes of tree, barge, and horizon. These silhouettes are clearly darker than the water and sky. Carefully drawn shapes are the keys.

PUSH BOATS, BATON ROUGE
Oil on board, 24 × 24"
(61.0 × 61.0 cm),
courtesy of Munson Gallery.

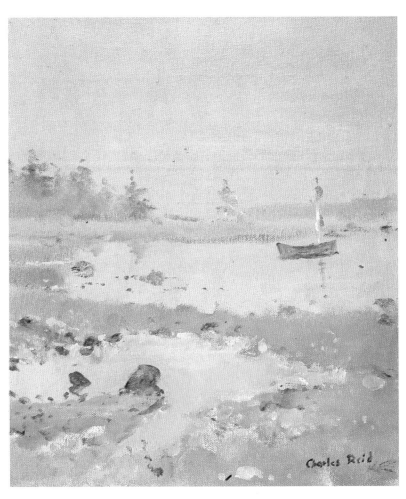

These two paintings were done from the same spot in front of our house in Nova Scotia. The first was done at high water in the fog and was to be an exercise for my next day's painting of the same subject. I did the second painting when the tide was out and the light was rather bright, conditions that made it easier to see more details. In spite of this, though, I remembered the straightforwardness of my first version and kept things simple here, too—note especially the foreground and the distant spruce.

TRAP SKIFF #1
Oil on panel, 18 × 16"
(45.7 × 40.6 cm).

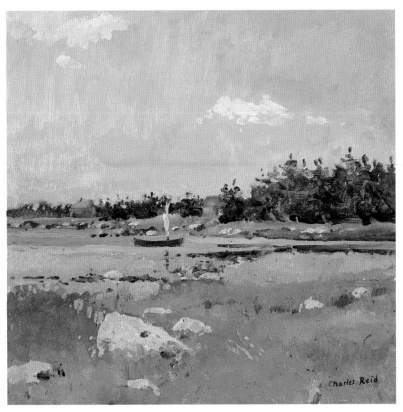

TRAP SKIFF #2
Oil on panel, 16 × 16"
(40.6 × 40.6 cm).

BACKLIGHTING IN LANDSCAPES

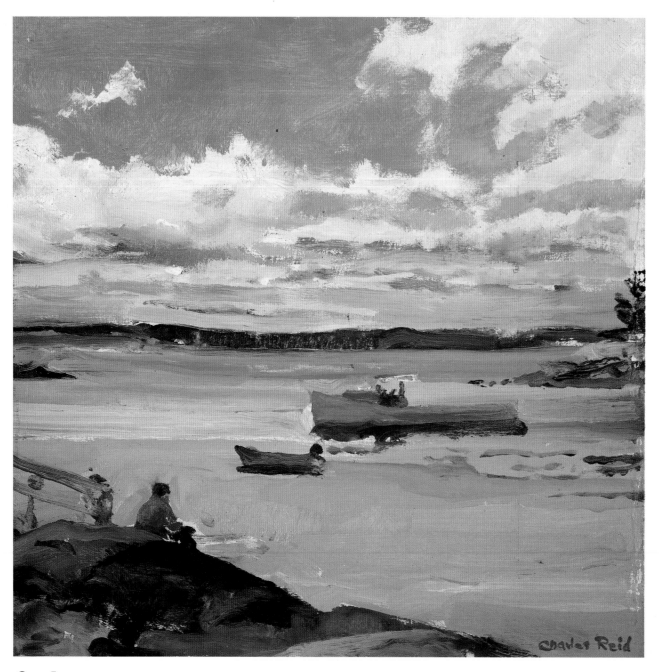

CAPE ISLAND

Oil on canvas, 16 × 16"
(40.6 × 40.6 cm).

This was painted on infamous Cape Sable Island, the very southwestern tip of Nova Scotia, where even Canadian fisheries officers fear to tread. Cape Islanders are a fearsome lot, a breed apart. In the picture, the sun is off to the left and under a cloud, illuminating the boats and foreground in such a way as to make them relatively simple, dark shapes. You do see some value differences, but the overall impression is that of dark shapes on a light background. I used ivory black with a little titanium white on the undersides of the clouds and in the reflection of the lobster boat. I use rather bright, "sweet" colors on occasion, and using black instead of complements to make grays tempers the sweetness. It's interesting how a touch of pure cadmium red right out of the tube—note the figure in the foreground—can spruce up a picture.

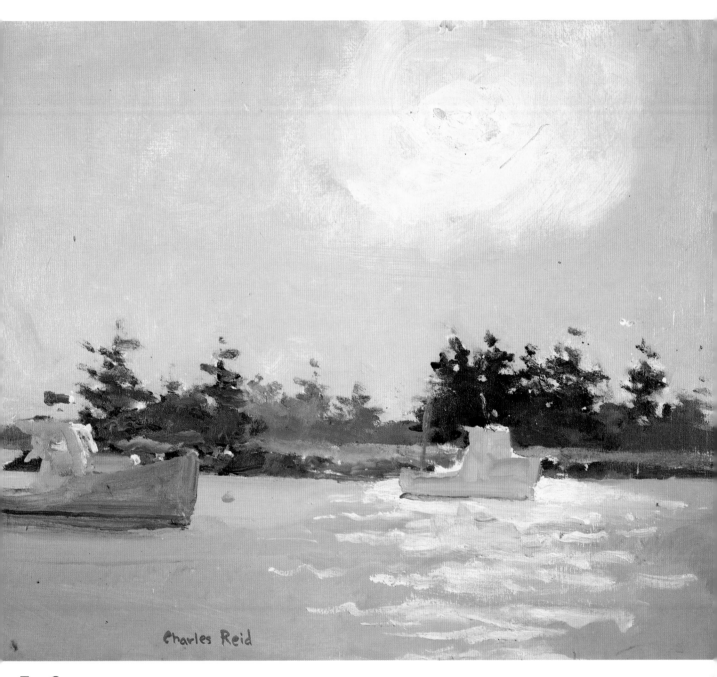

THE CREEK
Oil on panel, 18 × 24″
(45.7 × 61.0 cm), courtesy of Munson
Gallery.

I like this picture because it was fun to paint. I borrowed the idea of painting the sun from Fairfield Porter. I also borrowed the almost Oriental simplicity of his style. Note how the strong sunlight behind the trees and boats helps define their shapes. There was a lot of action in the water, but I managed to keep it simple so I could convey a sense of the sun's strong reflection.

BACKLIGHTING WITH FIGURES

When painting figures, we often concentrate on small forms—features, hair, wrinkles, and the like. But with backlighting, most of the subject is in shadow, making such details hard to see. It's very important not to imagine them, and not to put in things you know are there but can't actually see.

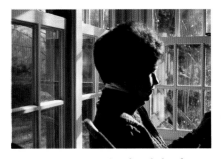

In this photograph of Judith, the interior details are practically lost. We see only the head shape and the simple planes that make up the front of the face. For the moment, don't worry about planes; instead, just think about the shapes of light and the shapes of shadow. If you can see the proportions and identify the shapes of light and dark and get them in the right places, you'll have a human head.

It's useful to plan your shadow and light shapes first with a pencil drawing. I actually outline my light shapes on the front of the face, then add my shading. Note that I make my shading lines diagonal to the boundaries of the figure. This helps prevent static and rigid drawing. If you draw your shading parallel to the boundaries you tend to isolate the forms. Also, I find it easier to keep my shapes accurate if I draw back and forth against a boundary. If I don't see separations between the face, hair, and shirt in shadow, I lose the boundary, even though I know it's there. I remind myself that I'm drawing the light and dark shapes rather than a face, hair, or a shirt.

For my color sketch, I use cadmium red and raw sienna in the warmer parts of the face, adding cerulean blue in the cooler parts. You could use any number of colors in the hair: ivory black, burnt umber or burnt sienna, ultramarine blue, and alizarin crimson. You might even try Hooker's green dark with the alizarin and leave out the blue. But if you worry only about colors and not about value and shape, you'll be missing the whole point.

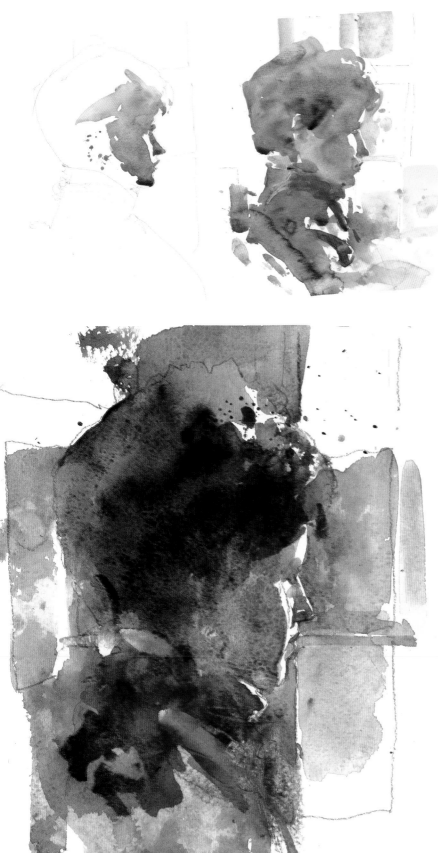

Always start your shadow wash where the shadow hits the light. Never work out of shadow toward the light. You want the most strength, the most precision and accuracy where the light meets shadow. Start with the form closest to the light. In the first step, far left, I carefully define the shadow shape that forms the nose.

As I progress, I work my skin-tone shadows away from the light, in this case from right to left. I work flesh color right over into Judy's hair, then add the hair itself wet-in-wet. This takes practice, so if you have trouble, just try some color swatches, running from a flesh tone into darker hair color. See if you can manage a smooth transition. Remember not to correct and fuss. You'll never know how paint works if you interfere with it.

I haven't painted my lights on the front of the face, I've left white paper. Our shadow shapes are our anchors; they give our forms substance. We must paint accurate and descriptive shadow shapes, the exact places where they nudge the light shapes, where they curve and straighten, where they create hard contrasts and where they dissolve to a point where you can't see the nudging. The ability to make sharp contrasts in some places and dissolve them in others is called edge control. It's important, but it should come after you've mastered value and shape. (When we soften edges we often sacrifice and lose clean value contrasts and accurate shapes.) My shadows were done with a first wash; don't rely on overwashes to finally arrive at the correct value. Too many layers of pigment can make for dull, opaque, dreary darks.

COMPOSING WITH BACKLIT FIGURES

WATERMAN AND REID PAINTING
Oil on canvas, 18 × 24"
(45.7 × 61.0 cm), courtesy of Munson Gallery.

This is a picture of myself (left) and a friend, Bob Waterman (right), painted in the studio with light coming in from behind us. Notice how Bob's figure connects with the window frame, and how the figure seems to blur into a whole. A few specific lights from behind bring the blur into focus. My figure, at left, has more light and shade in it, but notice how some boundaries get lost. Can you see where my apron stops and the background begins?

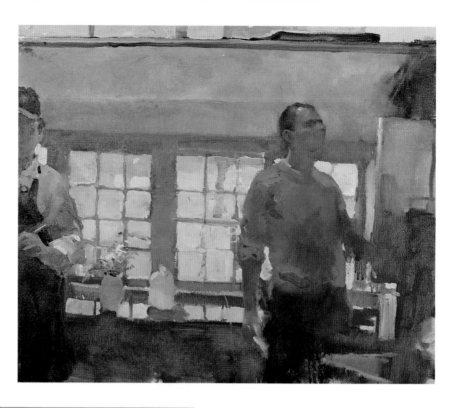

SELF-PORTRAIT
Oil on canvas, 38 × 26"
(96.5 × 66.0 cm), courtesy of Munson Gallery.

Here, the features are hard to see—a bit of light catches my spectacles and chin line, while the rest of the features are kept very close in value so that I don't disturb the overall dark value of the head. My silhouette is clearly a series of four different local value shapes—the hat, the head, the shirt, and the apron—which remain distinct in shadow, even though the details within them are lost.

Although the setting and lighting conditions in this painting are very similar to those in the painting above, note the prominence of the shadows cast by the objects on the two tables to the left of the figure. They match the color and value of my shirt and play a definite role in the abstract compositional design.

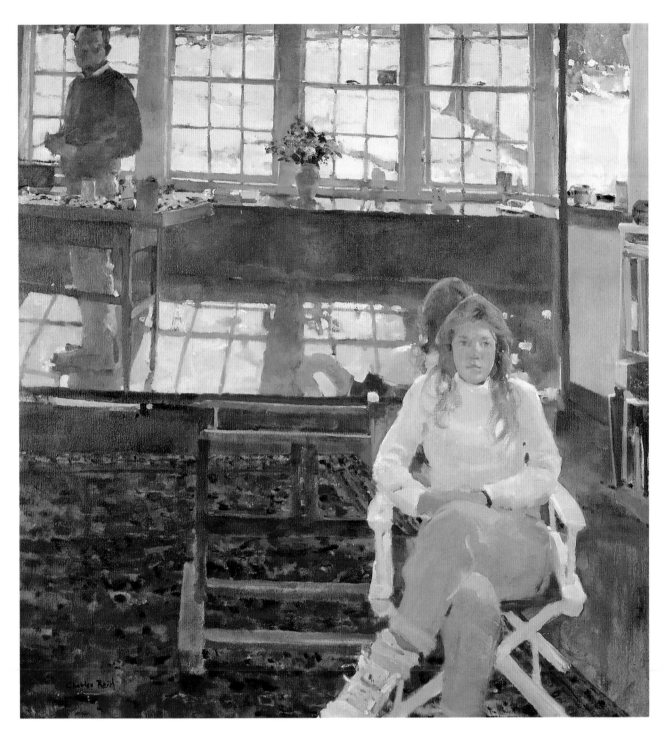

SARAH AND HER FATHER
Oil on canvas, 60 × 50″ (152.4 × 127.0 cm)

In this composition, my own figure is silhouetted by the light coming in from the windows behind me, but what might seem a little confusing is that I'm looking at myself in a mirror while painting Sarah in the foreground of the picture. You can see a fair amount of detail in her because in reality she's illuminated from the front—from the light through the windows, which she's facing—but also from the back, because she's sitting directly in front of the mirror and receives some of the light that reflects in it. While I read as a dark shape against light, Sarah reads as a light shape against dark, her white clothing and chair contrasting with the dark carpet and floor.

Although this seems to be a pretty complicated conceit, if you squint at the painting, I think you'll see a pattern of strong dark and light shapes that interconnect to form a cohesive and interesting design.

Part Four
FIGURES

Almost every artist attempts to paint the human figure at one time or another. If you're a beginner, perhaps you find this prospect a bit intimidating, if only because you worry about anatomy, gesture, and all the other aspects of rendering the human form "correctly," or perhaps because it's difficult not to identify with your subject as a living, breathing person. Ultimately, though, you must learn to see the human figure as simply a set of shapes, values, colors, lights, shadows, and contrasts that demand to be arranged in an expressive, interesting way. Skillful observation is the key to describing the human form convincingly; beyond that, as I demonstrate in this chapter with many examples from sketch classes, figures pose no more than the same kinds of design problems inherent in any other subject, animate or inanimate.

LEARNING TO RENDER THE FIGURE

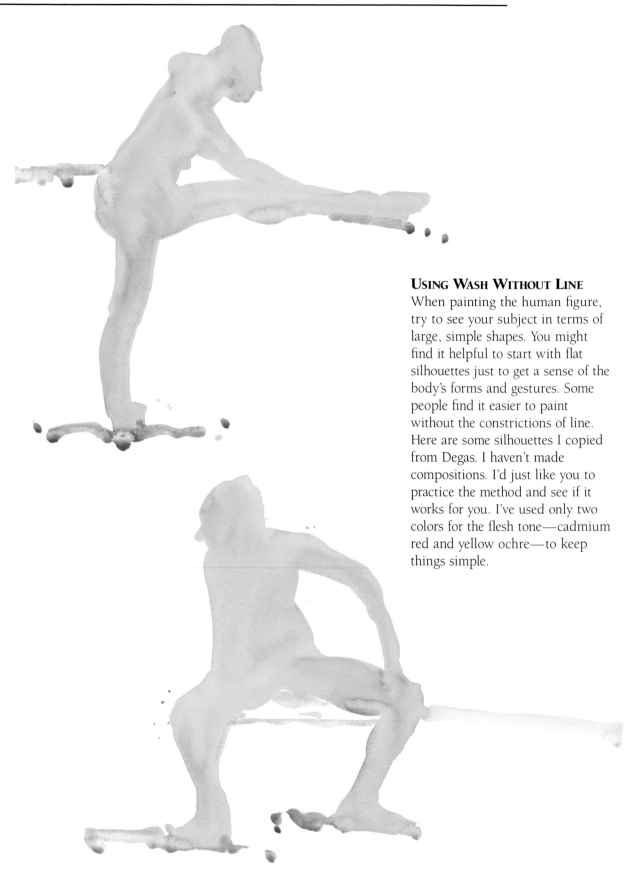

USING WASH WITHOUT LINE
When painting the human figure, try to see your subject in terms of large, simple shapes. You might find it helpful to start with flat silhouettes just to get a sense of the body's forms and gestures. Some people find it easier to paint without the constrictions of line. Here are some silhouettes I copied from Degas. I haven't made compositions. I'd just like you to practice the method and see if it works for you. I've used only two colors for the flesh tone—cadmium red and yellow ochre—to keep things simple.

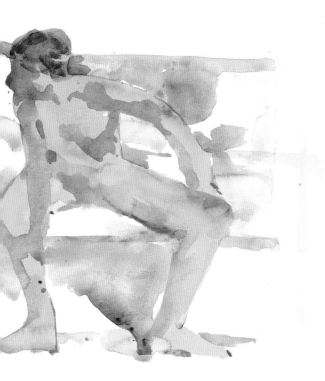

ADDING SHADOW SHAPES

Here I've added shadows to my silhouette, this time using a combination of raw sienna and cadmium red for the basic flesh tone. I've made the shadows warm by using cad red in them. Compare this figure with the two below, where I've overlapped my two single Degas dancers and added shadows, this time cool ones, in cerulean blue. I'd like you to experiment with colors to find the ones that work best for you—perhaps you prefer cooler to warmer flesh tones. It's your choice.

These pictures are rough and not "suitable for framing," but they do make an important point. You'll notice that in the single figure especially I didn't attempt to soften edges; I want you to see that clarity of shape is preferable to a fussy, overworked, overly softened rendering. Articulating light and dark shapes, both positive and negative ones, should be your main concern.

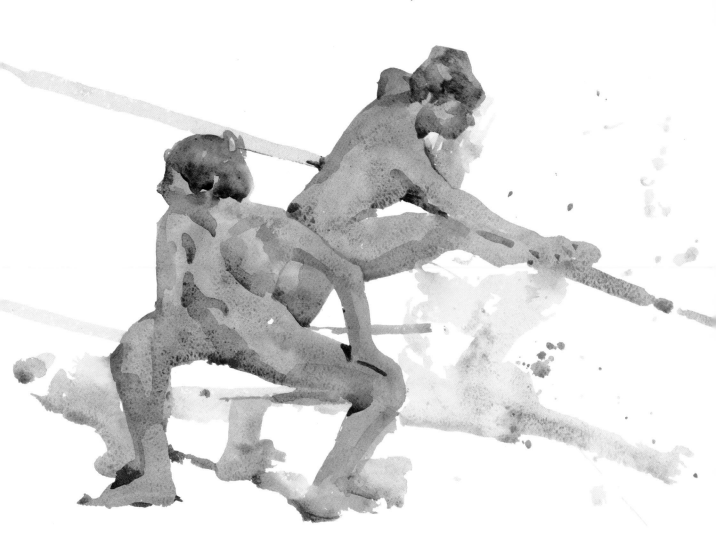

SKETCH CLASS

Generally I begin a figure sketch class by asking the model to take three- to five-minute poses, working up to longer, ten- to fifteen-minute poses. You don't need much to start with—a #2 office pencil, a block of watercolor paper, and just a few colors. I use cadmium red, cadmium yellow pale, and raw sienna. Cerulean blue is my cooling color. You'll notice that in my sketches the flesh tones are mostly cool. Working this quickly doesn't allow for fine tuning, and I find cooler color preferable to a poorly mixed hot red-orange flesh tone. Actually, it's not color itself that's so important here, it's honing your ability to mix color and value instinctively that counts. You have to get the value right with the first wash, since short poses don't allow for drying time and overwashes.

Instead of doing single-figure studies, I like to compose a picture by combining the model's various poses on the same sheet of paper, as if there were actually two or three different models posing at the same time. When I draw the figure from life, I use the basic contour method but with a little more flow to the line. Don't make a lot of little sketchy marks with your pencil; this wastes time. Practice using a single line. Be decisive. Accuracy of proportion isn't as important as accuracy of gesture.

Use a chair or the floor as a reference point to establish the relative positions of your model as he or she takes different poses. Concentrate on seeing and rendering large, articulate shapes—simple shapes with hard, definite edges where you want accurate and descriptive forms,

and softer edges when you want the eye to slide around and over a soft part of an arm or back. Edit out the many small details, value gradations, and colors that appear in reality. Think of the figure in terms of only one light and one shadow, along with a darker value for your negative shapes. Let the white paper stand for your lights. That means you'll just be painting shadow shapes and negative darks adjacent to the figures—but they must be accurate and descriptive if you're hoping for a human-looking figure. Negative shapes are critical in bringing the light side of the figure into focus. Render them at the same time as shadow shapes; negatives must never be afterthoughts. Crowd your picture space with people. Make some overlap, using negative shapes to bridge gaps between figures.

The figure second from the left was my first sketch of the session, a three-minute pose. I got the drawing done—you can see the model's boundaries, since I didn't erase anything when I superimposed the figure on the far left. I had only enough time to add a wash to the face. The next three poses lasted five minutes each; I placed the figures at whim but kept the height of the chair in mind so I could have the sense of four models on the podium instead of one.

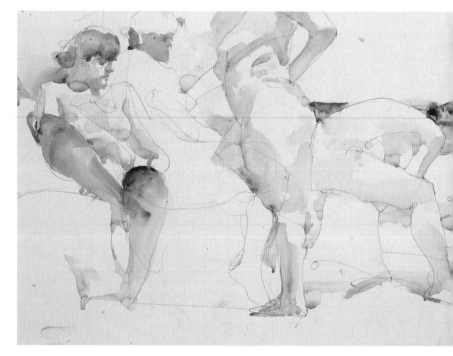

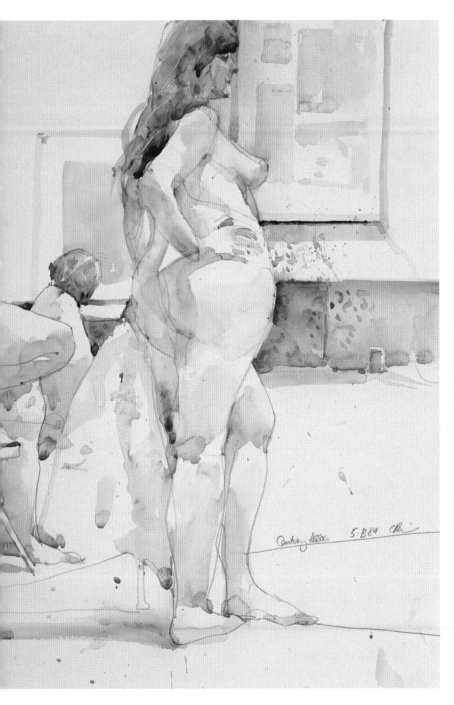

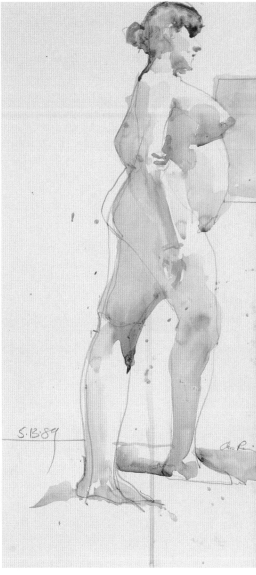

In this robust striding figure, shadow shapes are especially clear. Note how the cast shadow of one foot becomes a negative and brings the other leg into focus.

My palette for both of the sketches on this page consists of ultramarine blue, cadmium red, and raw sienna; the white paper serves as my lightest value. I've concentrated on shadow shapes. I'd like you to note how darker negatives set off the light parts and the cast shadows connect and anchor the darker parts.

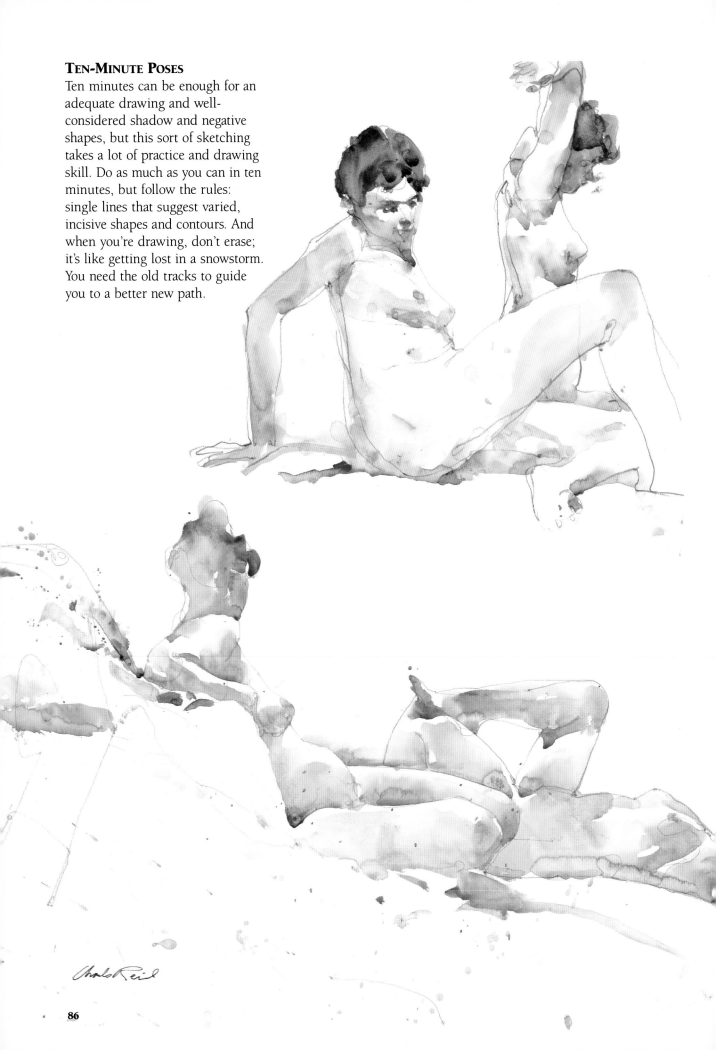

TEN-MINUTE POSES

Ten minutes can be enough for an adequate drawing and well-considered shadow and negative shapes, but this sort of sketching takes a lot of practice and drawing skill. Do as much as you can in ten minutes, but follow the rules: single lines that suggest varied, incisive shapes and contours. And when you're drawing, don't erase; it's like getting lost in a snowstorm. You need the old tracks to guide you to a better new path.

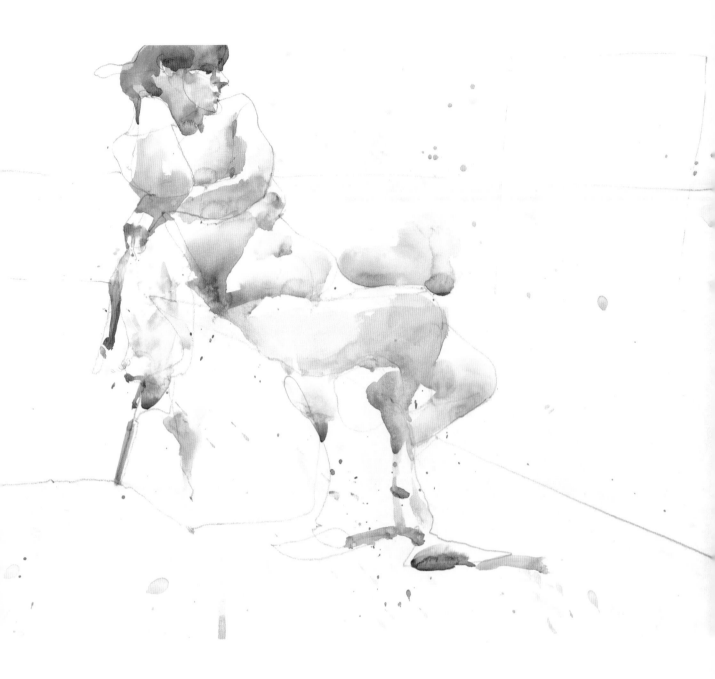

Once again I use a #2 office pencil for my contour-style drawings, making multi-figure compositions from a single model's various poses. I use the white of the paper for my lights, and very simple single-value darks. My palette is a little fuller than usual—cadmium red, cadmium yellow pale, raw sienna, yellow ochre, and cerulean blue, with a mixture for the hair that includes burnt sienna. (I *never* use burnt sienna or umber in flesh tones.) My use of color seems to be random—I put reds in places that weren't really red and add blues I didn't see. With only ten minutes to draw in a figure and then get some paint in the right places, I simply grab for color. But I'd like to impress upon you just how few colors and values are really necessary for describing your subject.

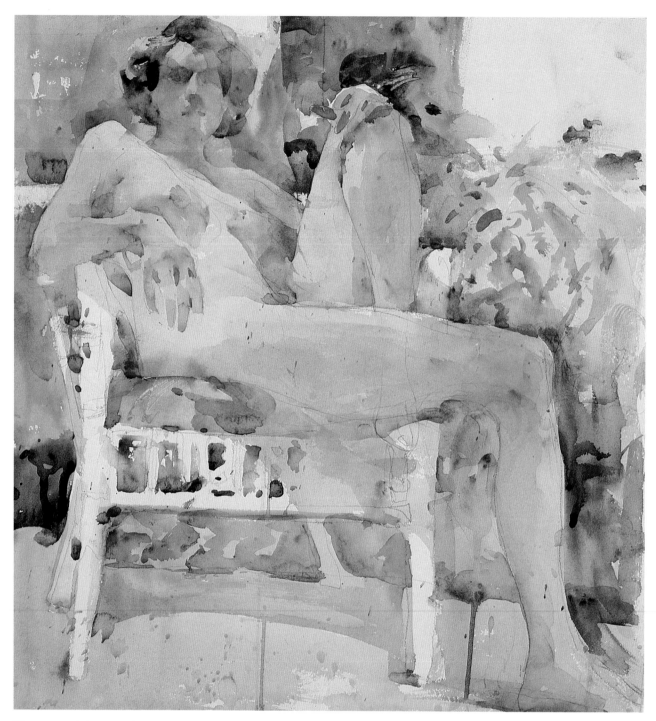

KAREN IN WICKER CHAIR
Watercolor on Fabriano
140-lb. cold-pressed paper, 15 × 15″
(38.1 × 38.1 cm).

Compare the darker negative background shapes with the lighter and darker values in the figure. Look for contrast and separation. Notice especially how I've sculpted the model's raised shoulder, which is out in the light, against the darker background; note, too, how I've managed to define the knee and shin of the extended leg. Now look for *blurs*, loss of definition—the places where your eyes seem to go out of focus. Squint at the picture and you'll see where the harder edges stand out, defining contrast between adjacent forms. Wherever it's hard to see a contrast, you have a blur, a merging of one form into another.

REDHEAD
Watercolor on Fabriano 140-lb. cold-pressed paper, 12 × 18″ (30.5 × 45.7 cm).

In this picture there's a lot of reflected light in the shadow side of the face, but compare this reflected, or "bounced," light with the white cloth the model is draped in. When you're in doubt about a lighter value within a shadow, compare it with a white that's out in the light.

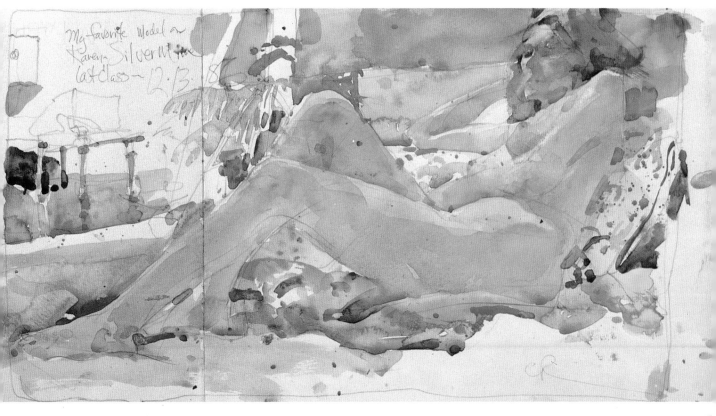

KAREN
Watercolor on Fabriano 140-lb. cold-pressed paper, 12 × 24″ (30.5 × 61.0 cm).

As you paint you must constantly edit, leave things out, simplify. Look at how I've managed to simplify the figure in this painting. Because they're both in shadow, the foreground arm and the rest of the body cease to exist visually and compositionally as two separate forms. Separation is lost. The shadow of the arm passes right over the hip into cast shadow, and the arm and back are united into a single shape.

CONTROLLING HARD AND SOFT EDGES

We soften or harden edges for several reasons. One is to lend variety—we don't want everything to be the same in a painting. Hard edges capture the eye; blurred ones let the eye slide by. Hard edges suggest contrast, while soft ones tend to make adjacent values more compatible. When you're looking at your subject, you've got to decide where to leave hard edges and where to soften them before you even make a mark on the paper or canvas. The best way to develop this ability is to practice squinting during the course of the day. Squinting time is as important as painting time.

I've made two swatches using ivory black as my dark, first in combination with a warm color (cadmium yellow), then with a cool color (cerulean blue). In both, which side of the black block catches your eye? Now look at the "soft" side in each, where you can see that there's some gradation in value. "Hard-edge" painters like Philip Pearlstein don't soften their edges this way, but they still need to make some adjacent areas compatible with each other, at least for variety's sake. This is accomplished by lightening or darkening the value of contiguous shapes to bring them together.

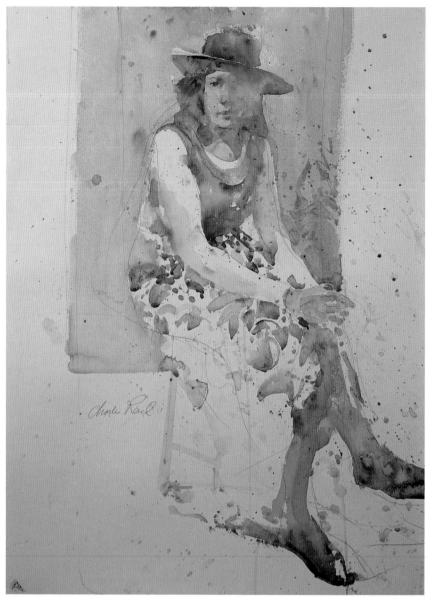

BLACK HAT
Watercolor on Fabriano Artistico 140-lb. rough paper, 24 × 18" (61.0 × 45.7 cm).

How do you make light values like skin and a white shirt compatible in some places with strong colors like red and darks like black? Study the picture. Compare the left side of the model's face, noting how it relates to the black hair, with the right side. And what did I do in the red sweater around the bustline to make a connection with the white sleeve? In both places I've altered values. You have to start out with a goal, and you can't count on your eye alone. I simplified the face and hair shadows. I didn't want the viewer to look there, so I lightened and "lost" the value of the hair on the shadow side. Why? I wanted the viewer to focus on the light side of the face.

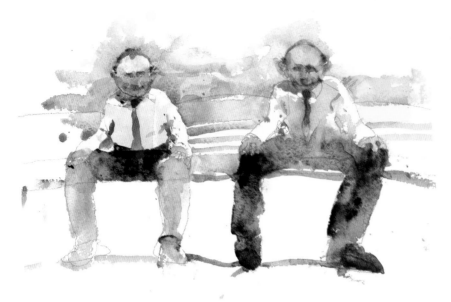

Another reason to soften edges and bring values together is to make an area appear to recede; similarly, you can make things come forward in a painting by sharpening edges and contrasting values. In this sketch of two men on a bench, the stomach of the figure on the left seems to advance due to the sharp contrast between the white of his shirt and the black of his trousers. The stomach of the man on the right, on the other hand, seems to recede, thanks to softening of value and shape, while his knees and feet come forward.

BLACK SLACKS
Watercolor on Fabriano Artistico 140-lb. rough paper, 22 × 30″ (55.9 × 76.2 cm).

Try to envision the model's black slacks in reality and how the light must have affected them. Checking the face, you can see that there was a rather strong light coming from the left. Naturally it illuminated the knees too, making them appear quite light in value, but if I'd painted them too light and made the waist too dark, I would have lost the idea of the legs coming toward me.

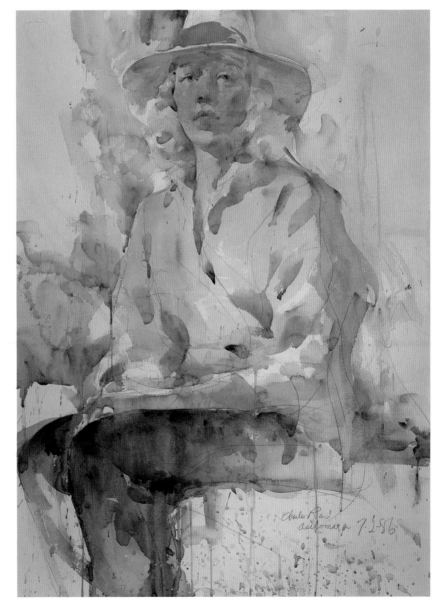

ADJUSTING FOR AN AWKWARD POSE

If in a sketch group you happen to get stuck right in front of the model or in another bad spot where the pose looks terrible and awkward, your only recourse may be to adjust values and lose boundaries to compensate. The sketch at right shows the actual values I saw in my subject, which might have made for a stronger painting had I stuck with them (compare this sketch with the finished picture on the page opposite).

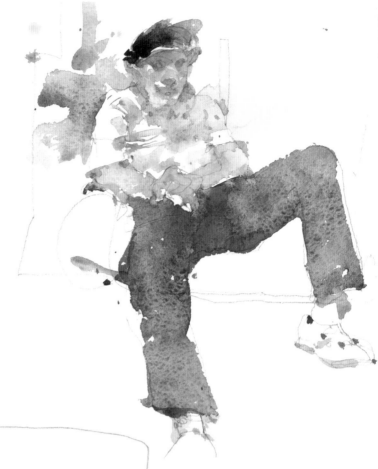

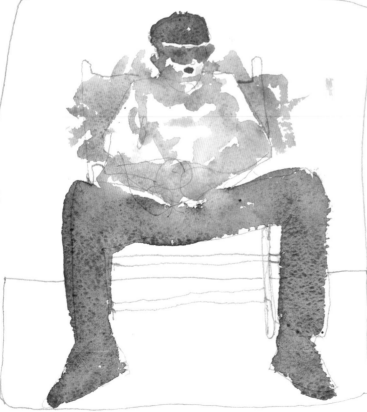

This sketch shows a more awkward, almost symmetrical pose with a lot of repetitious shapes—something you're bound to encounter once in a while. As an assignment, using my sketch, see if you can make an impossible pose like this work. I've indicated boundaries for a chair and the floor. What values would you use in these places to help disguise awkward legs? Again, using values in the background, how would you diminish the feeling of repetition in the arms?

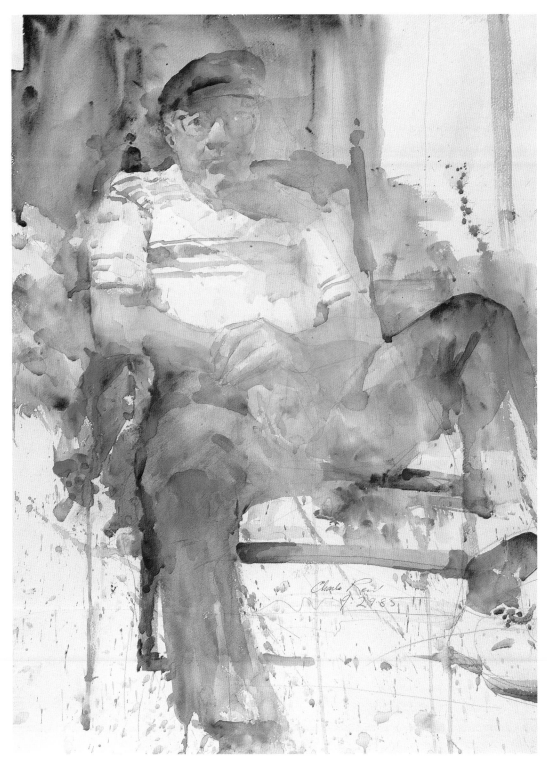

GREEK FISHERMAN'S HAT
Watercolor on Fabriano Artistico 140-lb. rough paper, 30 × 22″ (76.2 × 55.9 cm).

This was done as a class demonstration, and although it's not a great painting, it does show how I lighten a dark value to bring it together with a lighter adjoining value.

In reality, the model's lower torso was darker than it appears here, but I lightened this area in the painting so I could make the darker knees come forward. I left some of the white of the paper showing in the pants cuff to tie this area in with the white in the background.

A LESSON IN SOFTENING EDGES

Every form has some hard edges and some soft ones; no form is made up of just one or the other. Edges that face the light source tend to be hard, while those away from the light tend to be soft; edges in shadow are softer than those out in the light. In terms of the human figure, edges are generally harder on bony parts of the body and softer on fleshy parts. But perhaps above all, edges are harder in places you want to emphasize, and softer in whichever areas you want to lose.

You must remember that in any situation, some of the guidelines I've just mentioned might be at odds with one another. For example, you might see a hard edge out in the light but decide you want to emphasize a shape on the shadow side; in that case, you should promptly forget the "rules" and go with harder edges in the shadow.

Softening edges lets you show rounded, less defined forms, and lets you merge adjacent forms when you need to for compositional purposes. By skillfully manipulating values, however, you can still maintain distinct *shapes*; it's a matter of lessening contrasts in tone.

To soften an edge in watercolor, basically all you have to do is dampen the paper next to a wash that's still wet, allowing the wash to escape. Mix your wash, lay it down, then rinse your brush in clear water and give it one vigorous shake. Your brush must be absolutely clean. If you're worried about splattering, cover your painting area with a drop cloth or newspaper. The sketches below illustrate two possible approaches.

Here's one way to soften just a small section of a wash. After laying down color, I rinse my brush, then shake it and, starting about ¾″ away from the painted area, make a stroke toward and just to the edge of the section I wish to soften. *Don't let the brush actually go into the wash or it will ruin everything.* I'm simply making an escape path—the part of the paper I dampened with clear water will draw out some of the wash. I've found that mopping your brush with tissue takes too much moisture out of it, but if the brush is too wet after you rinse it, the water will attack and destroy the painted area with a "backwash"—you can see this happening in the forehead.

Here's a variation. I make a curving stroke with my damp brush toward the section I want to soften, barely touch it, and continue to move the brush out and away.

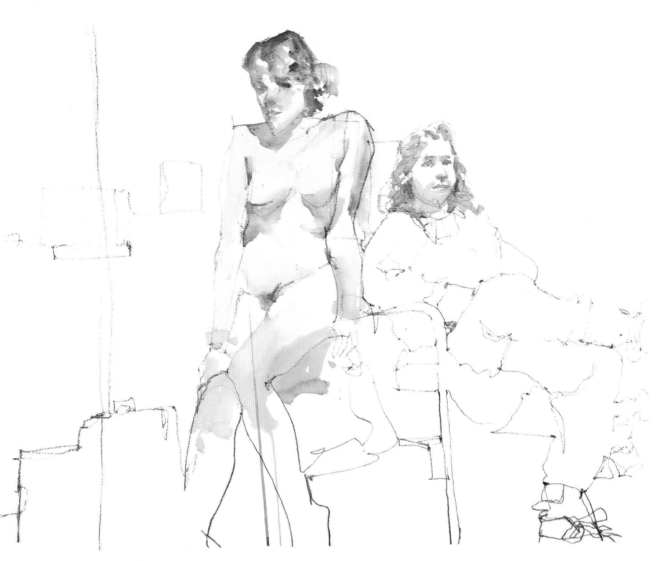

The picture above was a class demonstration showing how I soften small sections of a form. The torso of the standing model gives you an idea of what I mean by selective softening using the methods discussed on the facing page.

Notice the head of the standing figure where the edges have been overly softened and the structure of the face has been lost. I was more careful with the face of the seated figure; I kept some definition by leaving certain edges hard and precise.

Practice softening edges of wet washes. Make small color squares like the ones you see here and try to soften two sides while leaving the other two fairly crisp. Remember, in almost any form, you'd see both hard and soft edges.

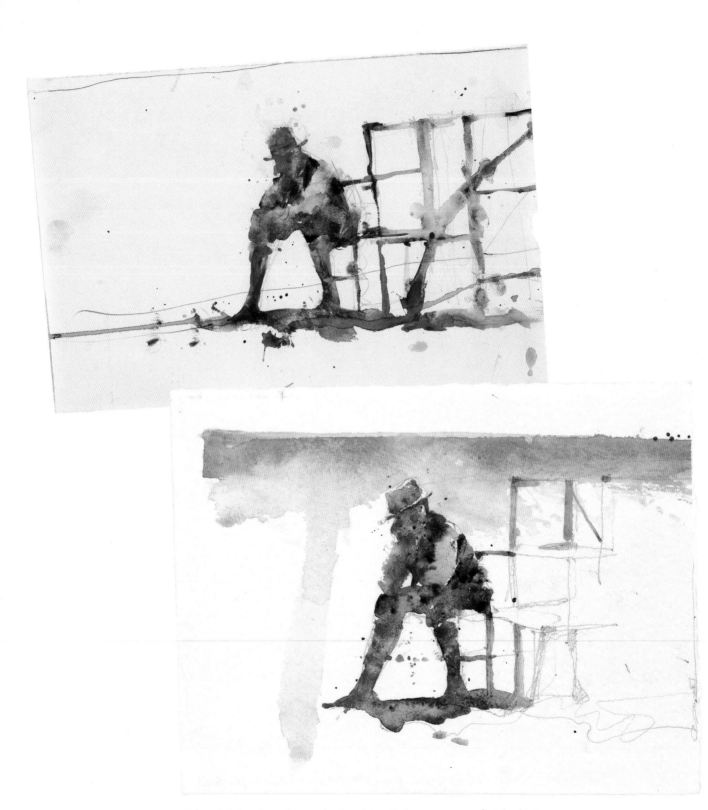

Often it's hard to detect the "makings" that go into a finished picture, so here are two examples from my sketchbooks that show a little more clearly how I work out my use of hard and soft edges and boundaries. In both sketches it's the silhouette that I want you to see. If I'd articulated all the physical boundaries and identified each part of the figure, I'd have lost the feeling of a dark mass against a light background. I softened the edges within the figure so that I could stress the harder-edged shape of his whole body.

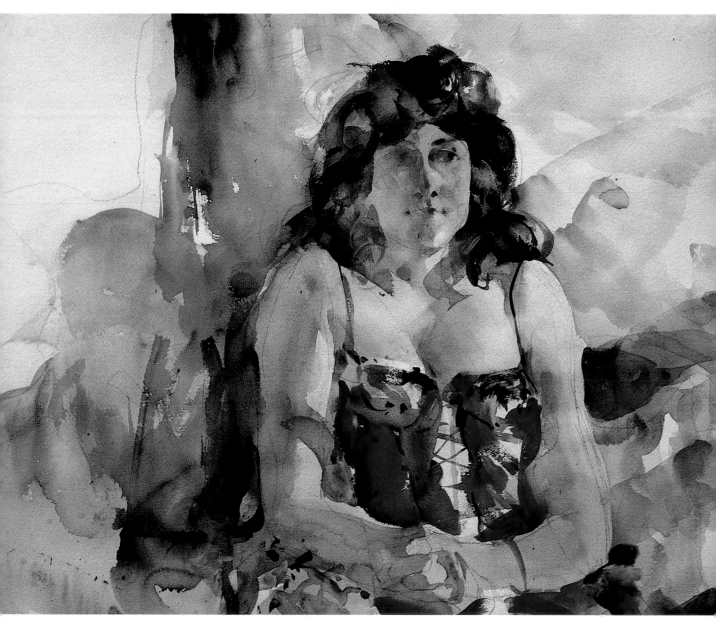

PARTY GIRL
Watercolor on Fabriano Artistico 140-lb. rough paper, 20 × 25" (50.8 × 63.5 cm).

Find the shadows and the cast shadows. Notice that the cast shadow on the figure's right arm and the one on her neck are much harder than the shadows on the torso. Note, too, how many hard edges I've used to describe her clothing, and the rather strong hard edges of the negative shapes that frame her arms. All of these definite shapes set up the contrasts I need to convey the sense of softness and roundness in the woman herself.

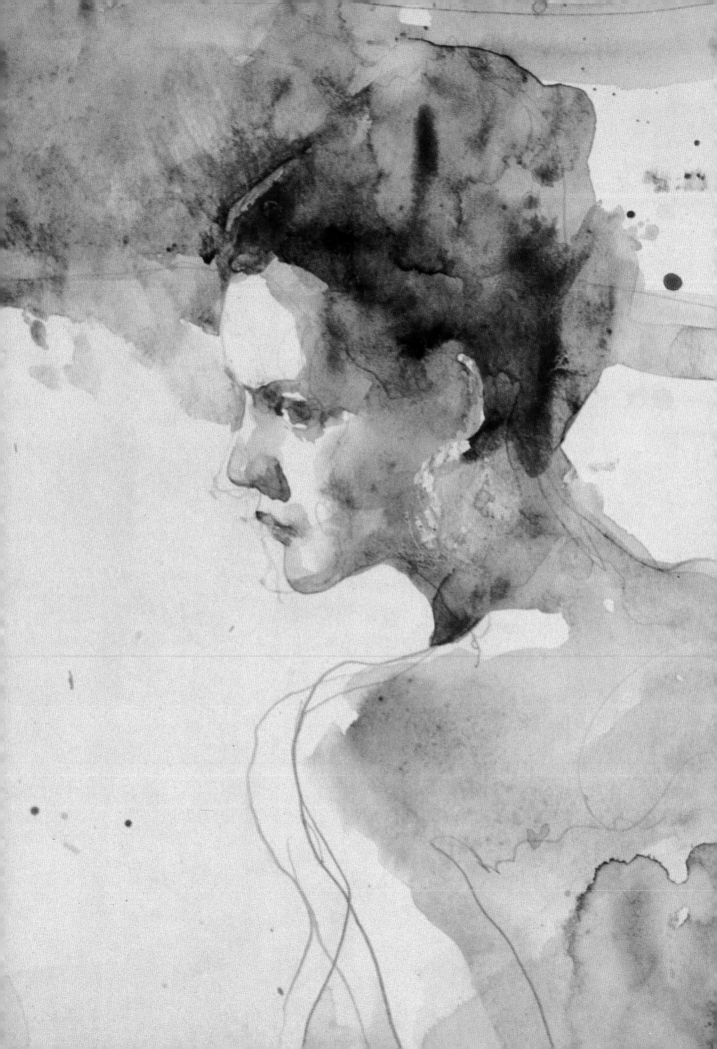

Part Five
FACES & FEATURES

Many of us regard the face as something that demands a greater degree of accuracy in rendering than other subjects; the face, after all, reveals a lot of a person's character. In our desire to capture personality, we scrutinize individual features too closely and render them as isolated elements, pasting them down in what seem like the right places—yet they neither add up to a likeness nor reveal much in the way of character. What's wrong? Faces aren't flat, two-dimensional forms. Every feature relates to another and to the overall structure of the head, and nothing is symmetrical. Eyes, nose, mouth, hair, neck—each is a component that must be integrated with the other to form a whole. In this chapter it's my aim to show you how to accomplish that.

Avoiding Rigid and Isolated Features

Many of us tense up when rendering another person's face. Perhaps you've experienced this; I do, even though I've drawn and painted countless faces. These are the symptoms:

1. Thinking of a face as unique, as being different from any other subject.

2. A desire to define.

3. Being so enthralled by an interesting face that you forget principles like maintaining form and bulk, simplicity, suggestion, color, and value.

4. Making everything look "normal" rather than emphasizing one area over another; we see too much, we look too hard and too long, so that everything looks important—and thus *nothing* is important.

I've tried to show what a head looks like when the artist renders facial features without relating them to the structure of the face itself, and renders the hair and neck as separate entities that also bear no relation to the face. Each element is painted discretely rather than as a component to be integrated with others.

If what I've described with my first sketch applies to the way you render faces, go back to the section on softening edges, then try this approach. Begin with the eyes. Paint the lids, iris, and brow. Rinse your brush quickly (you don't want the eye area to dry), shake it once vigorously, and draw it diagonally across the bridge of the nose to the

inside of the eye. Make a similar diagonal stroke upward from below the eye. I've left my sketch uncorrected so you can see how I attacked the other eye, plus the nose and mouth. Notice that I used just one shadow to describe the head and neck. Think shadow *shape*; don't stop a shadow at the chin line, let it flow right over into the neck. They are connected, aren't they? When you're painting the hair, don't think of it as a wig. I use what I call a "Morse Code" approach—I paint the hair along the side of the face with a series of strokes, leaving gaps in places that will relate to the lighter values in the face and thus tie the face and hair together.

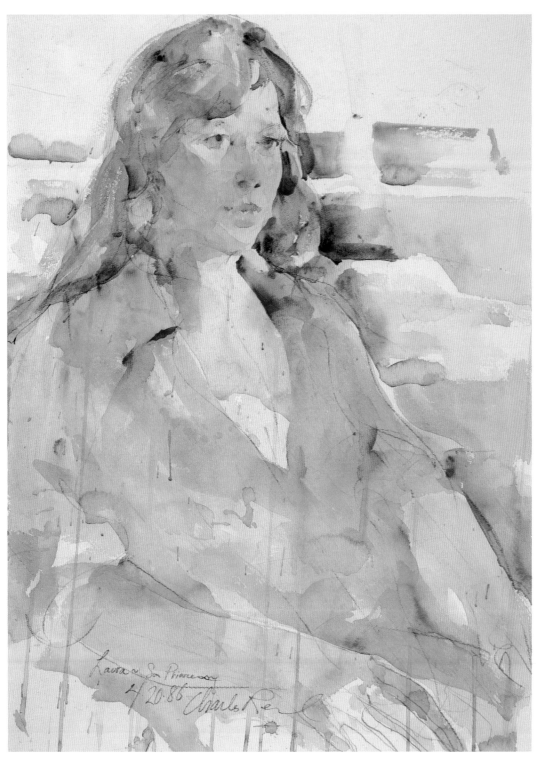

PRINCESS CRUISES
Watercolor on Fabriano Artistico 140-lb. rough paper, 25 × 20″ (63.5 × 50.8 cm).

Compare the two sketches opposite with this painting. See how, in the painting, feature boundaries disappear in places, merging with adjoining skin and hair. Note the "stop-and-go" approach in the hair. The nose and mouth are painted as bits of color rather than as rigidly outlined forms filled in with paint. A hint for when you're painting a face that's influenced by subtle shadows: Add some warm color to the tip of the nose. This will help make it come forward.

MOUTHS

If you draw and paint the mouth as a separate, isolated part of the face, it will look like the examples you see here, which give no sense of the bulk or shape of the teeth underneath the skin and look like cutouts you'd paste down. You need to lose some of the firmness as the edges of the lips pass over and around the teeth. It's easy to forget about what's under the surface, but actually the lips reflect the structure of the teeth and jaw. It's this underlying structure that makes a person look the way he does, so you can't paint just the superficial elements and expect to capture your model's particular character and likeness.

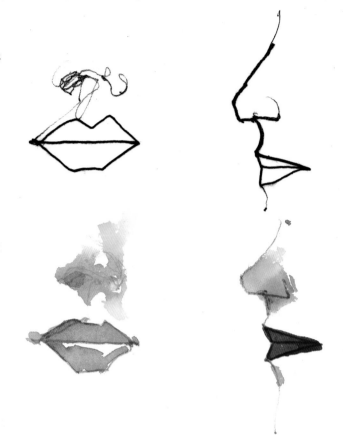

DRAWINGS AFTER VERMEER

One of the artists to whom I often look for inspiration is Jan Vermeer, the seventeenth-century Dutch painter whose work is infused with a quiet, understated elegance and precision of form of resounding beauty. When you're in doubt about what constitutes good picture-making, go to Vermeer.

I made these two drawings after *The Red Hat* (1667), a painting by Vermeer in the collection of the National Gallery of Art in Washington, D.C. My purpose was to show you that to avoid flatness in rendering the mouth (or any other feature, for that matter), you must avoid making solid lines that have the same width and stress. If you draw the mouth with solid lines, it seems to lie on a flat plane instead of describing a rounded form. It looks stiff. In each of these two sketches, using Vermeer's painting as a guide, I've drawn definite lip boundaries but made diagonal strokes across the mouth to give it the appearance of bulk and roundness.

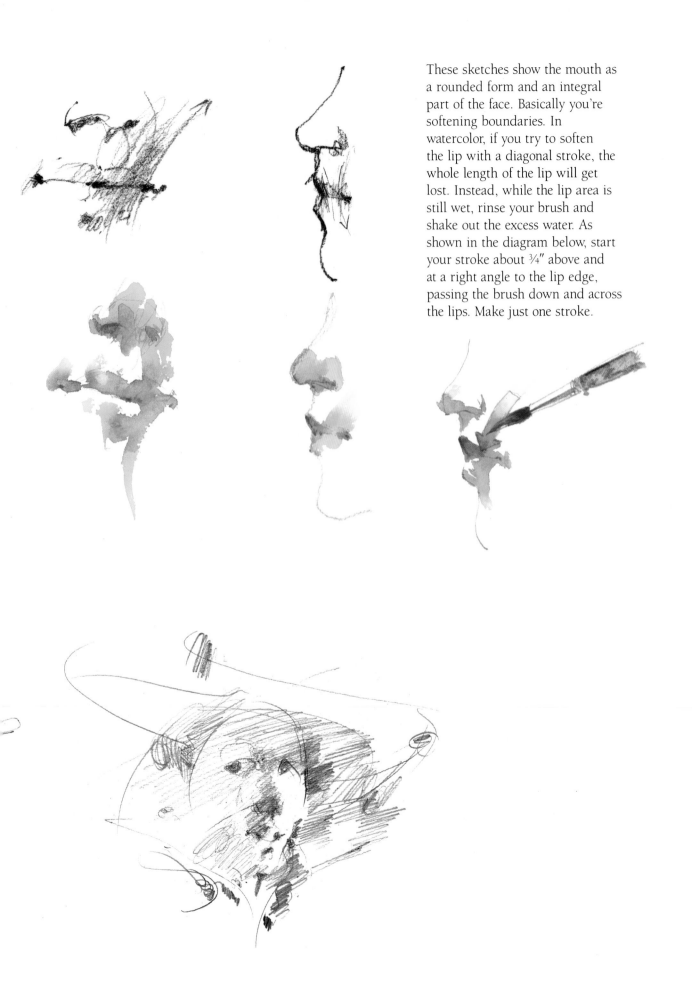

These sketches show the mouth as a rounded form and an integral part of the face. Basically you're softening boundaries. In watercolor, if you try to soften the lip with a diagonal stroke, the whole length of the lip will get lost. Instead, while the lip area is still wet, rinse your brush and shake out the excess water. As shown in the diagram below, start your stroke about ¾″ above and at a right angle to the lip edge, passing the brush down and across the lips. Make just one stroke.

Study Margarita's mouth in both the finished painting and the sketch. I wanted to give it a definite form without isolating it. The shape of the mouth is horizontal, yet I make diagonal— almost vertical—strokes through it to establish a connection between the lips and the rest of the face.

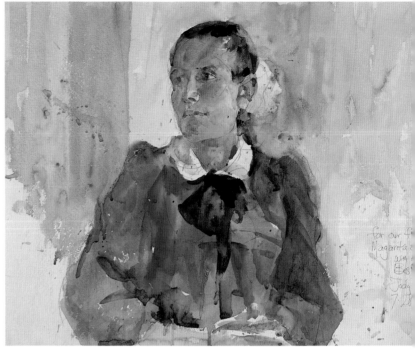

MARGARITA
Watercolor on Fabriano Artistico 140-lb. rough paper, 22 × 30" (55.9 × 76.2 cm).

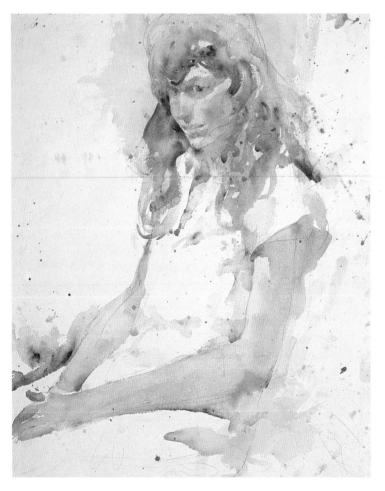

SKEPTICAL WOMAN
Watercolor on Fabriano Artistico 140-lb. rough paper, 30 × 22" (76.2 × 55.9 cm).

Look at how just a few simple strokes define the figure's mouth. The shadow in the indentation of the chin gives the lower lip its volume, while the upper lip is a combination of small bits of bright color at either corner and a subtle blurring beneath the nose.

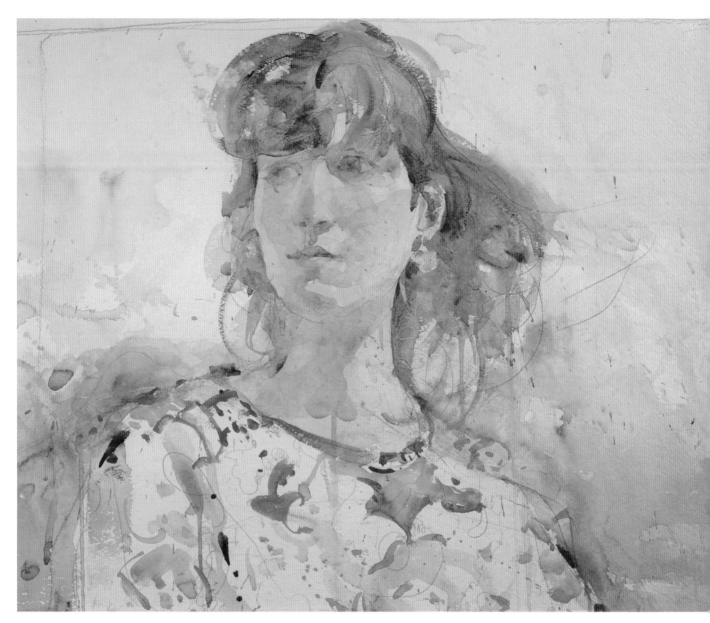

KAREN II
*Watercolor on Fabriano Artistico 140-lb.
cold-pressed paper, 22 × 30"
(55.9 × 76.2 cm).*

When rendering the face, avoid symmetry. Never repeat a shape, not in the mouth, the hair, or in any other feature. In reality, no one's face or figure is perfectly symmetrical. The more closely you observe the human form, the more obvious the subtle differences become. This model's mouth is most certainly not symmetrical; for one thing, her lips don't form the idealized bow shape that many beginners would have drawn. Note how her top lip comes forward as a result of the contrast between the light and dark values in that part of her face, and how her lower lip merges with the shadow beneath it, yet maintains its shape and the suggestion of fullness.

EYES

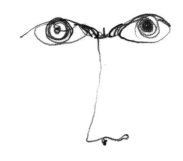
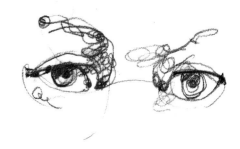

Don't think of eyes as dark dots or empty ovals, as I've drawn them here in my first sketch. Students usually see the iris clearly enough, but not the sockets and the form of the eyeball beneath the lid. When rendered without any suggestion of depth or physical volume, the eyes seem to float on top of the face rather than sit within it.

My second sketch illustrates another common problem: squeezing the eyes together.

To draw eyes correctly, as they appear in my third sketch, start with either the left or the right one and observe the upper lid, studying the shape of its curve. Keeping your pencil anchored to the paper, draw the iris and the pupil, then the socket, the fold of

skin above the eye, and, with a lighter line, the lower lid. Go back to the inside corner of the eye you've just drawn and, leaving a space equal to the width of that eye, skip across the bridge of the nose to begin the other one. The eyes must be correct, because they'll be your measuring tool for the rest of the face.

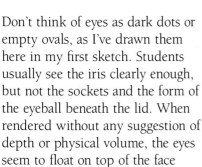

My "mistake" sketch, near right, is a somewhat fanciful version of all the things that can go wrong in rendering a face. The shoulder line is too low, the neck looks like a piece of pipe, and features seem to be pasted on. In the correction sketch, far right, I've obviously integrated the different parts of the face and considered their proper proportions and positions in the head structure. Notice how the mustache, mouth, and nose work together as a unit.

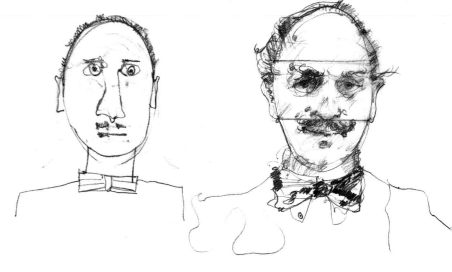

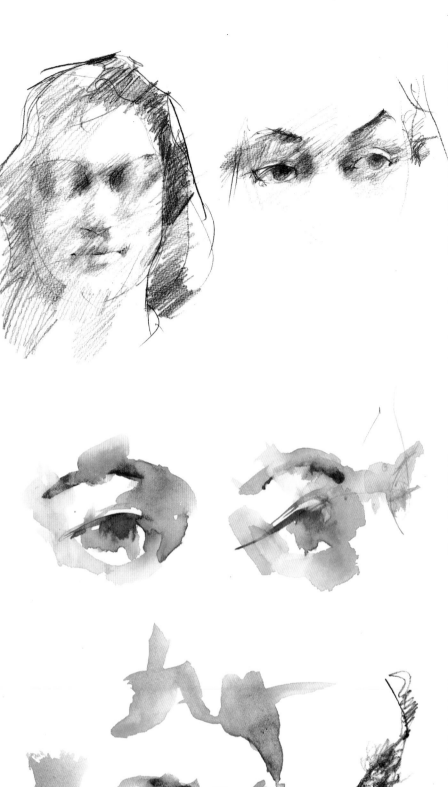

The drawing at far left gives you a general impression of the head's structure. Try copying it, aiming to create the sense of a human face, molding the bulk with your pencil and leaving out feature details.

Next, as in my sketch at left, add the lids and iris on top of your structure drawing, making sure these details don't dominate the overall structure. The partnership should be equal. Things to look for: The upper eyelid overlaps the top of the iris; the bottom of the iris sits on the lower lid. The top lid is often darker than the lower lid. The eyes, like other human features, never match each other exactly.

It's good to stress the outside boundary of the lid that's facing the light, but you should let the inside of the lid get "lost" as it merges with the socket cavity next to the nose, as you see here.

Even in a partial side view, the eyes remain one eye's width apart. As the head turns away from view, the eyes shorten in width but their height remains constant. The eye that's farther away becomes shorter than the closer one; draw the closer eye first as your measure.

Students often want to pull a partial side view frontward. To avoid this, establish the triangle formed by the nose, eye, and cheek, as illustrated at near left. Check where the tip of the nose is in relation to the far cheek and eye.

107

NOSES

Don't draw a shadow *around* the nose and mouth, as I've done in the "mistake" sketch at right. The boundary between shadow and light usually goes down and into the nose, and the shadow always goes into the upper lip, as in my correction sketch below.

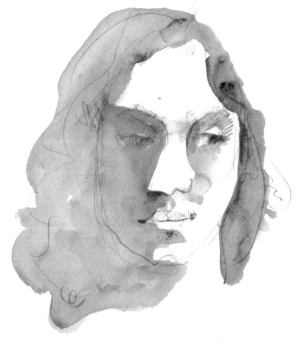

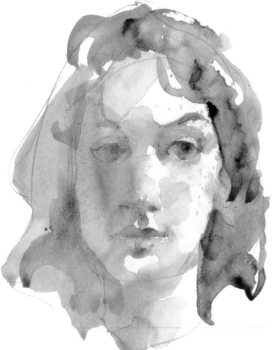

The mouth and nose should always be part of your shadow pattern, not separate from each other. If this is too subtle in my painting, look at the pencil sketch below, where it's a bit more obvious. When you're painting a nose, add a bit of warm color to the tip (more red and less yellow); this helps it to project. A washed-out nose sinks into the face.

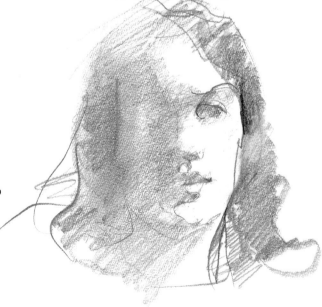

Here you can easily see the shadow shape that links the nose and mouth. Try to think and paint laterally as well as vertically, not just in a single direction. Don't forget the dip between the top of the nose and forehead. It's a bridge, a connecting passage between the eyes. Look for a softening of the edge of the eye socket and a slightly darker value.

SKIN TONES

As I discussed in the color chapter, the colors you use in skin tones are important, but mixing is more so. Try to give a sense of warmer color in the nose, mouth, ears, and cheeks, and cooler color in the side planes, lower face, and forehead, as in this little watercolor sketch.

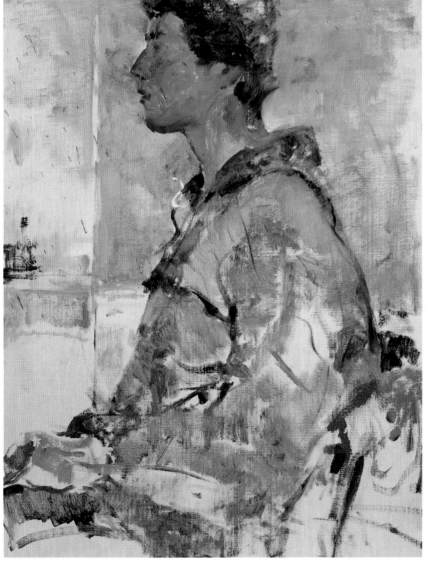

SWEATSHIRT
Oil on canvas, 23½ × 18½"
(59.7 × 47.0 cm).

When you're painting in oil, balancing the warm and cool tones in the face is not much different from when you work in watercolor. Note my use of cool blue-gray under the brow, at the side of the nose near the eye socket, at the temple, the lower part of the cheek, and the shadow on the chin; the nose, mouth, ear, cheekbone area, and part of the forehead are all infused with warm reddish hues, with crimson accents in the nostrils and lips. Do you see how this kind of color treatment helps to "sculpt" the face?

HAIR AND BEARDS

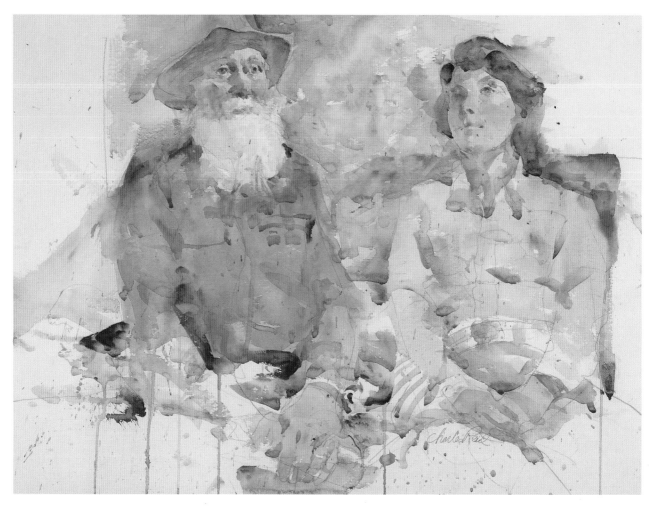

Like any other feature, hair and beards shouldn't look pasted on, applied over a face instead of being a part of it—but that's what can happen if you establish a definite value contrast between skin and hairline. You need places where there's no contrast, soft edges where skin and hair can merge into each other. You always need some contrast for the sake of clarity; just don't get carried away with separations. Remember to squint to find appropriate places for both hard edges and softness.

In this painting, note how the whiteness of the man's beard relates to the same light value in his forehead and the other parts of his face in highlight. Note, too, how I've combined his mouth and beard—you know the mouth is there, but it's not a crisply defined form. Nothing about the beard is hard-edged in relation to the face; there's only the contrast between its whiteness and the warm dark value I've used for the tip of the nose, and small accents that frame the beard near the shoulders.

MATT AND PHYLLIS
Watercolor on cold-pressed paper,
22 × 30"
(55.9 × 76.2 cm).

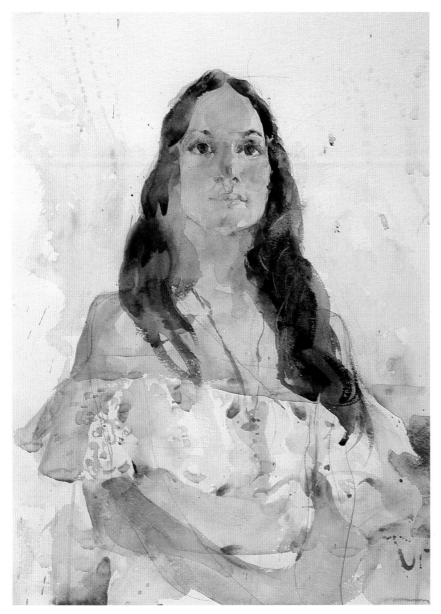

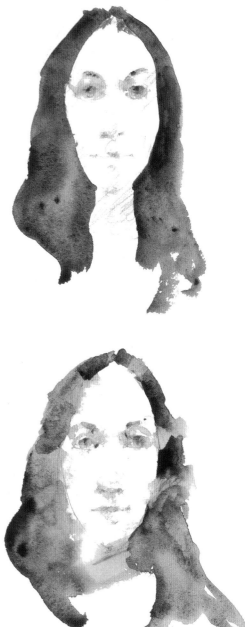

SAN MIGUEL
Watercolor on Fabriano rough paper, 30 × 22″ (76.2 × 55.9 cm).

Dark hair next to a light complexion often looks wiglike. Never paint hair totally around and parallel to a face; try painting and drawing parts of it at a diagonal. Leave some breaks along the boundary between skin and hair so it won't look as if it's been pasted around the face. I've also made some lighter transitional sections, as you see on the left (shadow) side of this painting, where I don't want a lot of contrast. It's hard to see where the hair stops and the skin begins.

Compare the two sketches at right. The top one has a somewhat exaggerated "cutout" look that's usually not desirable, but this image is graphically stronger than the one below it, where I've created transitions between the hair and face that are perhaps too subtle.

PUTTING IT ALL TOGETHER

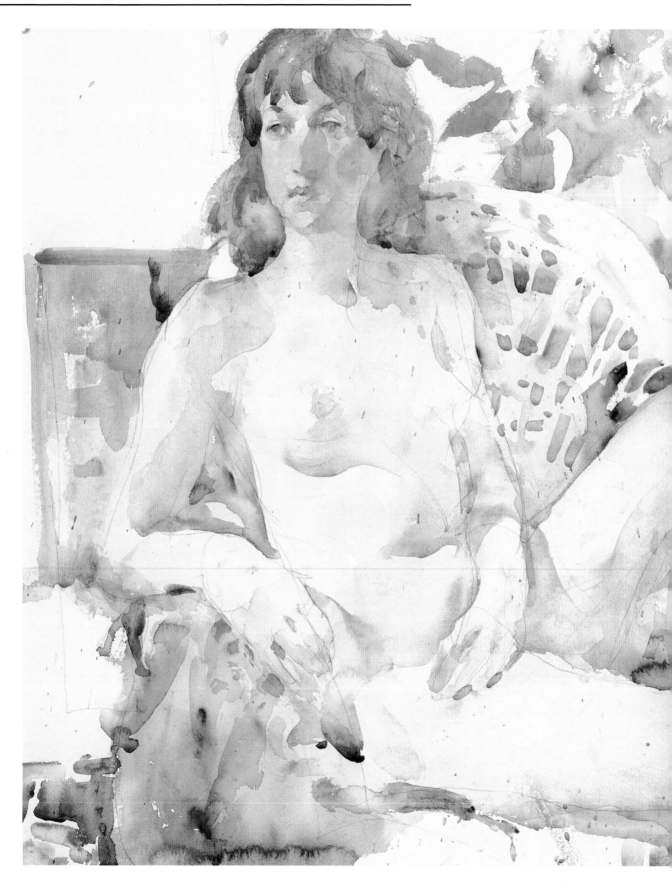

HOLLY
Watercolor on Fabriano rough paper,
18 × 24″ (45.7 × 61.0 cm).

Rather than worrying about the face you're painting,
try to think instead of rendering the light and
shadows in your subject with accurate and carefully
formed shapes. You're better off if you don't get
bogged down with distracting thoughts of capturing
your subject's likeness—in the beginning, if you can
get the right shapes, the rest will eventually follow. In
this painting the shadow and light shapes are simple
and uncluttered, and are of equal importance in the
face and the rest of the figure. Eyes, nose, and mouth
interrelate, and the hair is attached to the head in a
natural-looking way—it's darkest where it meets the
lightest, highlighted part of the face, and is lighter and
more softly defined on the side of the face that's in
shadow. Think of the part of the hair that's in shadow
and the shadow itself as a unit in the beginning. Don't
make a lot of fuss over value contrasts in shadow;
underplay them. Keep your important contrasts out in
the light where they belong—where you want the
viewer's eye to go, as here, where the upper left part of
the face grabs our attention.

A PORTRAIT DEMONSTRATION

In this photograph, light and shadow are in very high contrast—a necessary and useful factor if you're new to painting people. I lit the model with a 100-watt household bulb and a photographer's reflector. The photo shows only two values, and that's all you should start with. Trying for subtleties is the cause of most student failures, so stick to the obvious.

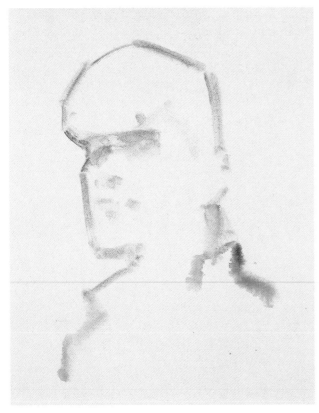

Because it's not always feasible to stop in the midst of painting to photograph the work in progress, I've re-created my key steps with the oil sketches you see on these two pages. I started by making a drawing on white canvas, applying burnt umber with a #3 bristle brush using lots of turpentine and no white pigment. For this kind of work, don't mix an oil medium with the paint or it will take forever to dry. The turpentine wash lends the background some nice texture and variation. I've used an angular drawing style—sort of a contour drawing with a brush. This makes you start out with definite shapes. If I hadn't articulated the cheek, I wouldn't have known where to put the nose. It's important to get a strong silhouette shape, so don't be sketchy when you draw. You could practice this on cheap paper pinned to a board.

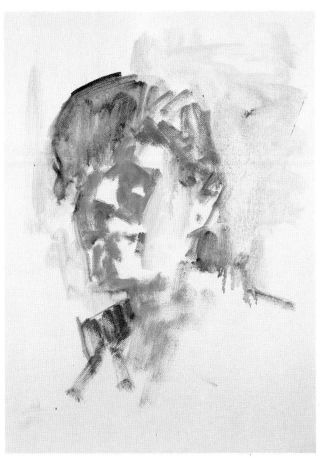

Switching to a #5 long, flat-bristle brush, I block in the hair using burnt umber in shadow, adding a bit of cadmium orange to the areas out in the light. I keep my paint thin. The parts of the skin in shadow are cadmium red light and raw sienna, with just a bit of white. The collar and background get a wash of cobalt blue. Notice how I let some canvas show and vary my strokes—they're T-shaped. When painting in oil, always start with your mid-darks; they are your foundation. Don't mix colors with a palette knife, use your brush instead—otherwise you'll waste a lot of pigment. If you're following my steps as I paint, at this point, take a bit of cadmium red light out to your mixing section, then rinse your brush in turps and dry with a tissue. Now mix some raw sienna with the red, and don't let one color overpower the other. Clean your brush and add white as needed—sparingly. Your shadow shapes should describe the human head without the help of individual features. *Don't* try to correct with light values.

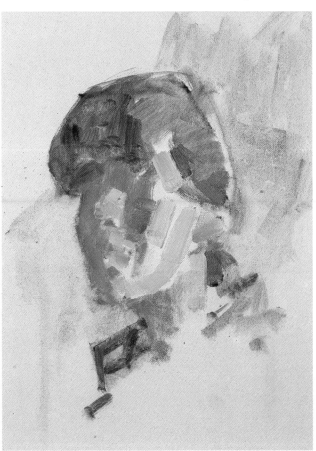

In this stage I add some lights. With a clean brush I take some white out to the mixing surface, clean the brush again, and add just a tiny amount of cad red and cad yellow. I stroke a bit of cerulean blue along the chin line and in the lower and upper parts of the shadow. (Don't do this yourself if you have trouble mixing correct values. When you add a complement, your value darkens and you have to add more white.) The main thing is to keep the integrity of the shadow shapes. That's why I lay the light values alongside the shadow shapes and don't attempt to soften or blur the structure of the head. Think of *pieces of paint*, a phrase that describes so nicely the placing of strokes of the right value and color next to each other. Blending is fine, but think of Seurat and the Pointillists, who arranged dots of color and value to make the viewer's eye do the work.

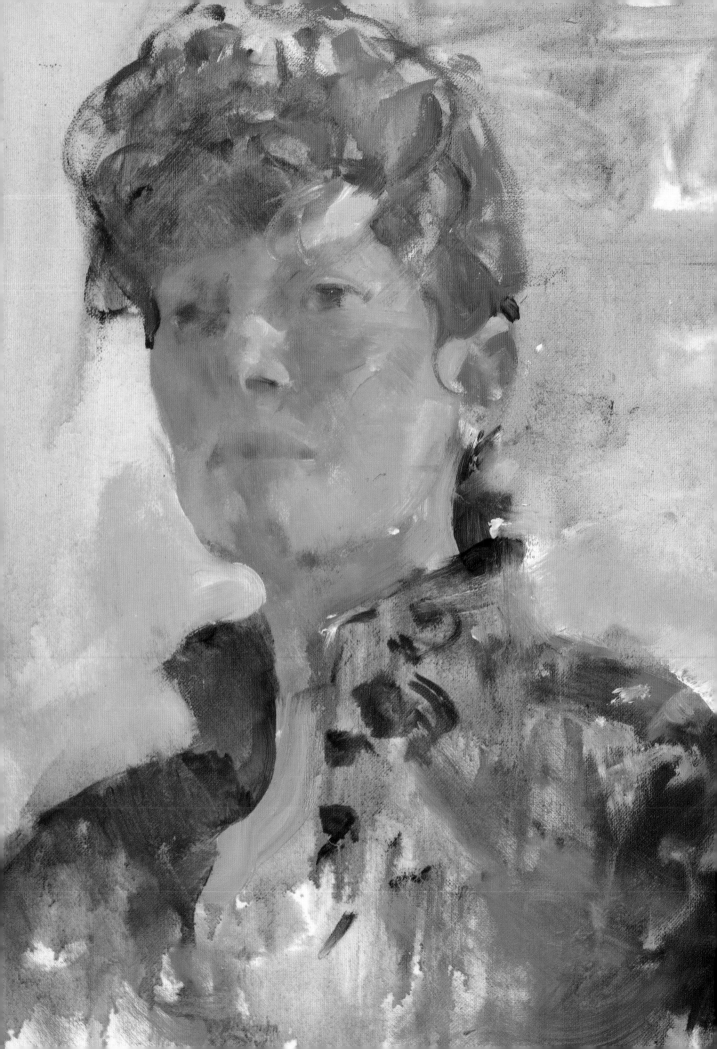

FANNY
Oil on canvas, 18 × 15½"
(45.7 × 39.4 cm).

In the finished painting, values are closer and subtler; there isn't as much contrast between the lights and darks as there seemed to be in the actual lighting situation (as seen in the photograph). Yet this is what most of us see when we decide to paint someone. Still, I couldn't have managed this picture if I hadn't first seen the model's face as a simple, two-value problem. The subtleties were secondary and didn't sway me from maintaining one shadow and one light.

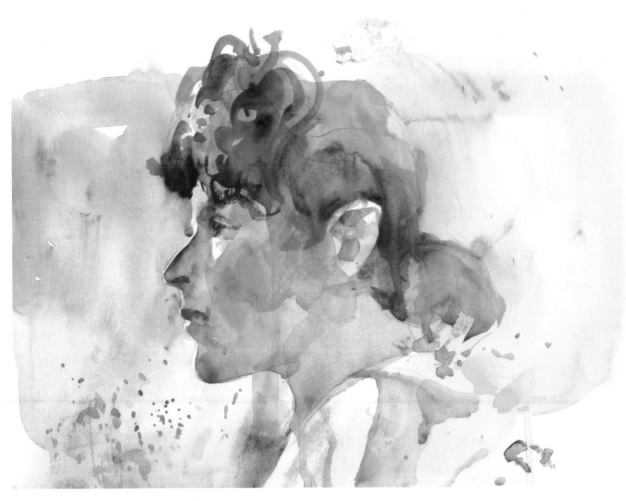

In this watercolor of the same model, which I did before painting her in oil, I used backlighting. You can see minor value variations, yet I've still managed to keep the integrity of shadow. It's clear that light is light and shadow is shadow. *Rule:* All values in the shadow must be darker than values in the light, even if the shadow contains reflected light. Reflected light must be darker in value than main light.

FANNY
Watercolor on cold-pressed paper,
9¼ × 14" (23.5 × 35.6 cm).

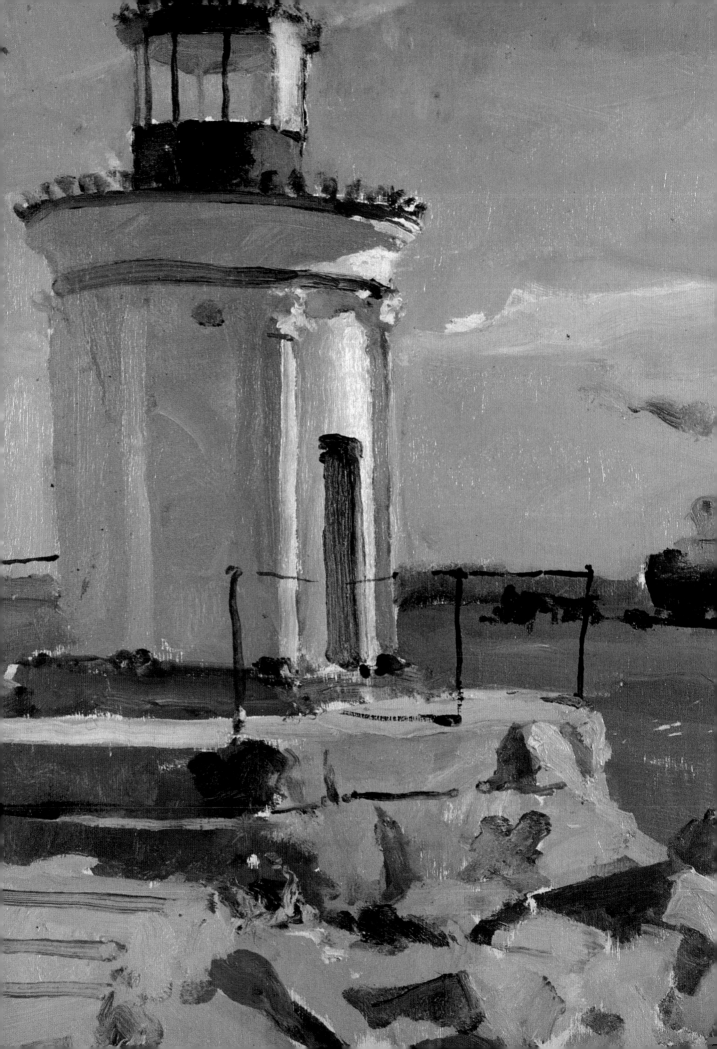

Part Six

DESIGNING PAINTINGS

We see too much. Everything looks important; we're taught to think symmetrically and to give equal attention to all areas. But that doesn't make for effective painting. Good pictures are built on a foundation of solid design, which depends not on specific subject matter but on your ability to perceive any subject—figure or otherwise—in terms of color, value, and shape. These are the essentials, the building blocks. Learn to work not from your head but from your eyes. Your real aim is to paint the light, not the thing itself. You have to train yourself to see your subject objectively rather than to identify with it, and to treat what's in front of you as a simple design problem—keys to good picture-making.

SEEING ABSTRACTLY

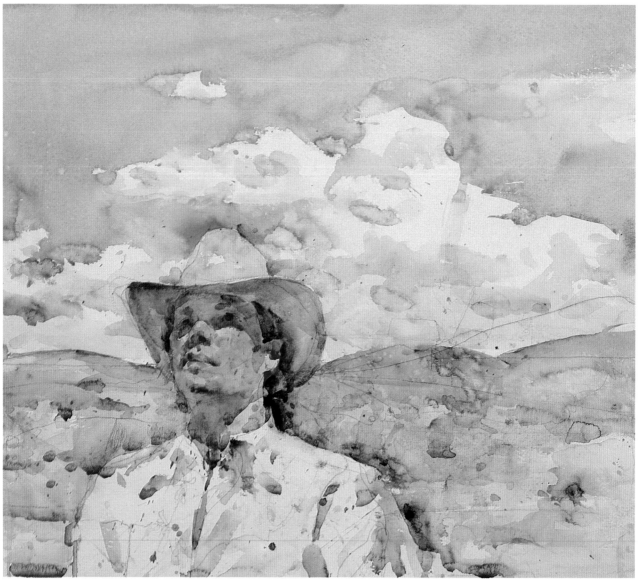

Many students separate one known physical form from another when observing and painting a subject. A hat is separate from a face and from the background, and so on. This makes for isolated forms where you don't really want them. Instead, think of painting the light shapes and the shadow shapes—forget actual physical separations and concentrate on the similarity or difference between connecting and adjacent *values*. Here, the underside of the hat brim and the shadow it casts on the face are similar in value, so I minimize the separation between these two physically distinct areas and think of them as a single shape that exists in contrast to the lightstruck lower face and crown of the hat. Painting light and shadow transcends the physical boundaries you see in reality.

SANTA FE
Watercolor, 22 × 30″ (55.9 × 76.2 cm).

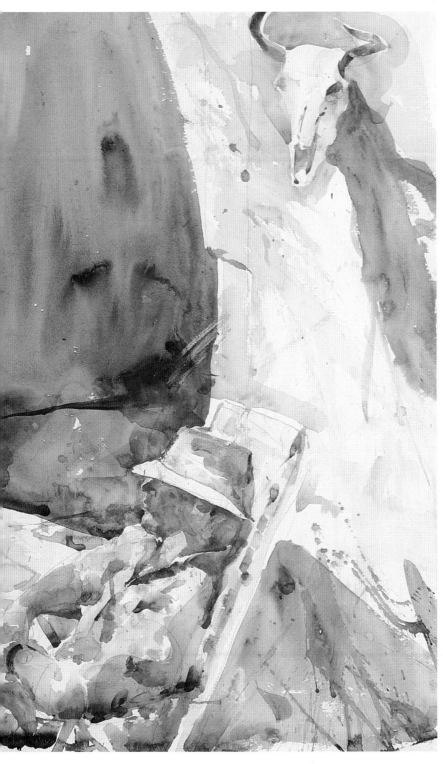

NEW MEXICO
Watercolor, 24 × 18″ (61.0 × 45.7 cm).

Most of my students view composition as little more than a comfortable arrangement of objects. I try to point out that composition is better thought of as a design of light and dark shapes—an abstraction. That's what we have here. The steer's skull is important only because of the shadow it casts. The man is important because the shadow on his face creates a contrast with the lightstruck hat and shirt. The doorway isn't a doorway at all but a rather dark shape that forms the core of the picture.

SELECTING A FOCUS

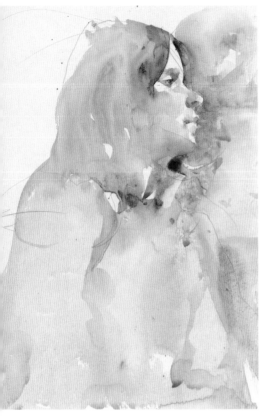

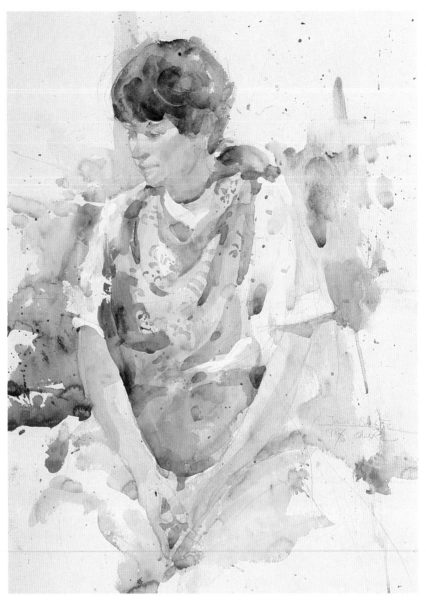

MENDOCINO
Watercolor and oil on paper, 14 × 10¼"
(35.6 × 26.0 cm).

One of the hardest things to teach is selection—choosing what's important in a picture and underplaying what's not. "Less is more" is an excellent credo. Three shapes are better than four, two better than three. What you leave out of a composition is at least as important as what you put in it. In *Mendocino*, for example, the model's hair was actually dark, her sweater pale yellow, her collar white. To direct the viewer's attention to her face, I've brought these different elements into one simple form.

JUDITH
Watercolor, 30 × 22" (76.2 × 55.9 cm), collection of Judith Reid.

In Judith's face I played up the eye that's closer to the viewer, the lightstruck cheek, and dark hair by using contrasting values and maintaining fairly firm edges. Compare this area of focus with other parts of the painting. Note the elements I've selected as important and how I've brought them to your attention.

ACCENTUATING CONTRASTS

In both the sketch at left and the finished painting below, I stress the contrast between light and shadow in and around the nose, forehead, and chin. This is the part many students miss. I get your attention by using harder edges, stronger contrasts, maybe more intense color. I underplay the big shadow on the side of the face because I want the viewer to look not there but at the model's features. When working in a lighting situation like this one, where the model is partly illuminated from the front and partly silhouetted against a light background, your eyes will tell you to make the side and back of the head dark, where you'll see the obvious, darkest shadows. But is this where you want to draw attention? Big darks anchor the eye. On the other hand, the darks around the features are subtle—but aren't the features often the point of the face? Certainly they're more important than the back of the head.

RED HEAD
Watercolor on cold-pressed paper, 18 × 24" (45.7 × 61.0 cm).

DEFINING MAJOR VALUE SHAPES

JUDITH'S ROSE
Watercolor, 7 × 10″ (17.8 × 25.4 cm).

The cliché about not seeing the forest for the trees certainly applies to painting. You can't understand the idea of a forest if you concentrate on each individual tree; you have to see the whole forest as one mass against another one, the sky. Two major shapes, two major values. Study Winslow Homer's paintings. His forests, seas, and skies identify so beautifully because he was a master of seeing important shapes and casting aside confusing individual details.

In *Judith's Rose* the flower, jar, and tabletop all have some darks in them, but they're kept in a minor key. The major dark is the background. Look at the painting, then close your eyes. What do you remember? Did it look like the sketch you see at right? What you should have recalled is not color, not subtlety of tone, just the bare bones of simple value contrast, the dark negative shape that makes the light shape emerge.

KEEPING DARKS FROM BECOMING TOO DARK

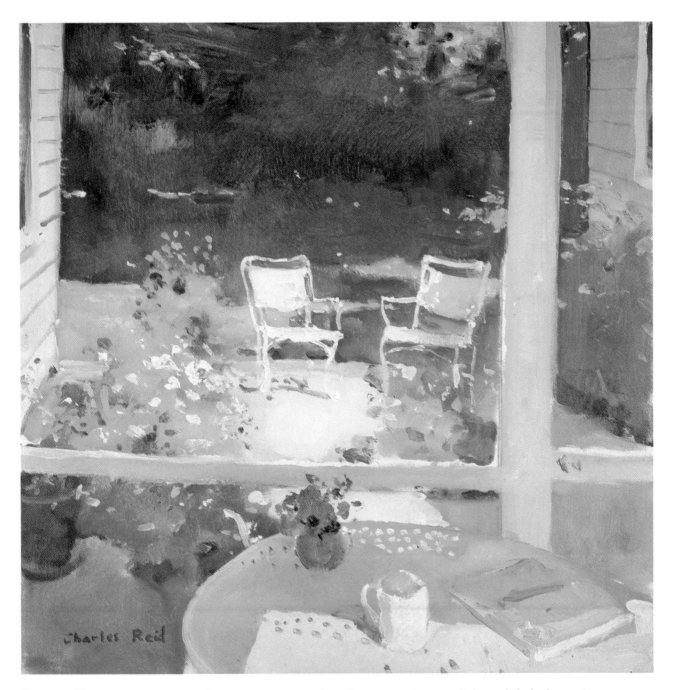

SUMMER PORCH
Oil on canvas, 24 × 24" (61.0 × 61.0 cm), collection of Judith Reid.

Once you are on track and can organize your light and dark shapes into large, cohesive masses, you must worry about making the darks too dark. If you're not careful, darks can become a wall, admitting no sense of air and atmosphere. As I studied this scene before painting it, the woods looked murky and black after I had stared at them long enough. But when I studied the chairs for a while instead, the woods seemed to lighten a value or two. This was the value I needed to paint.

NEGATIVE AND POSITIVE

I did this watercolor sketch of a ballet dancer from a black-and-white photograph in my motel room after a class one day. Photocopies and newspaper photos are perfect for reference because they do so much of the editing for you. Copying such images in paint is great practice for developing your perception of strong design and strengthening your compositional skills. In this particular case, many of the figure boundaries became unimportant; it was the bold negative and positive shapes of light and dark that made the photo so special and expressive and that make the painting work.

"THE EFFECT" VS. "THE BIG BLUR"

I use the word "effect" to mean much the same as focal point or center of interest in a painting, but my teacher Mr. Reilly didn't like these two terms. He felt that a good picture should have many focal points that would lead a viewer's eye through it. In essence, then, "the effect" is an area of exaggeration in a picture. It's where there's stronger, more intense color or harder edges or sharper value contrast, usually on the part of the subject that's closest to the light. An artist might use just one of these strategies or might use all three; it's all a matter of personal approach.

WHITE SHIRT
Watercolor on Fabriano 140-lb. rough paper, 18 × 12" (45.7 × 30.5 cm).

White Shirt is a good example of what I mean by "the effect." The critical boundaries between light and dark are well defined in this painting; contrasts are strong and edges sharp. It's the accurate shape of light that makes a face look human. I concentrated just on painting the lights and darks in the right places, and the features came into being on their own. Using the white paper for my lights, I started this picture with my darker mid-values as I would if I were painting in oil. As always, I began with the darks in the eye socket and eye, continuing with the nose and its shadow and cast shadow, then the mouth and the shadow under the lower lip. The cheek and chin planes came afterward; it's best to work from the planes closest to the light toward the shadow, not from the shadow toward the light.

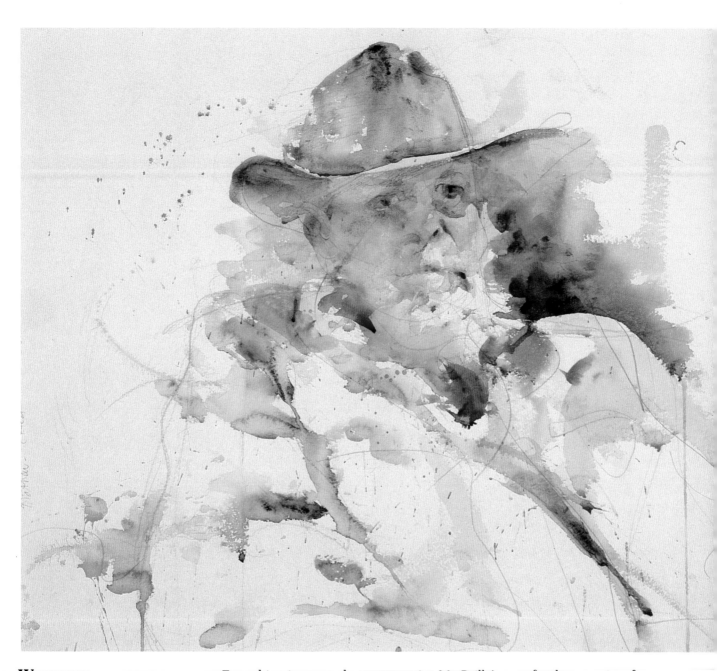

WESTERNER
Watercolor on Fabriano 140-lb. rough paper, 20 × 20″ (50.8 × 50.8 cm).

Everything in nature has an opposite. Mr. Reilly's term for the opposite of "the effect" was "the blur." In good design, just as there is one area with precise edges and strong value contrast, there must be another area with compatible values and soft, lost edges. In *Westerner*, note how things within shadow get fuzzy and out of focus, as opposed to the places where I've painted the light and the precise edges it makes where it hits the nostril and the fold of skin beside the nose.

WHITE BEARD

Watercolor, 15 × 12″ (28.1 × 30.5 cm).

This sketch carries the principles of "the effect" and "the big blur" to an extreme. I've used my darkest darks on the right side of the picture to frame the head, and created a precise edge where the shoulder and the top of the head meet the background; also, the features on that side of the face are fairly crisp in definition. These elements in focus are all the more compelling to the eye because they are offset by the way I've blurred forms and lost value contrasts on the left side of the picture, the part of the model that's in shadow.

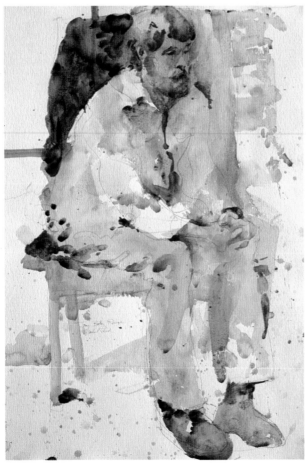

REVERIE

Watercolor on Fabriano Artistico 140-lb. rough paper, 30 × 22″ (76.2 × 55.9 cm).

Most student paintings suffer from an overall sameness; I did this picture as a demonstration to show my class how to avoid the problem by using the principle of "effect" vs. "blur" in an exaggerated way. I painted the figure's shirt and light background simultaneously as a single blurred area, using the same colors and values for both and ignoring the boundaries I'd drawn in pencil. Then, to establish my main focus, or "effect," I used my darkest dark for the big negative shape that frames the figure from behind, the exaggerated edge between dark and light clearly delineating his body and giving it a sense of volume. I added just a touch of dark color up by the other shoulder when the paper was dry to show a bit more separation between the figure and the background.

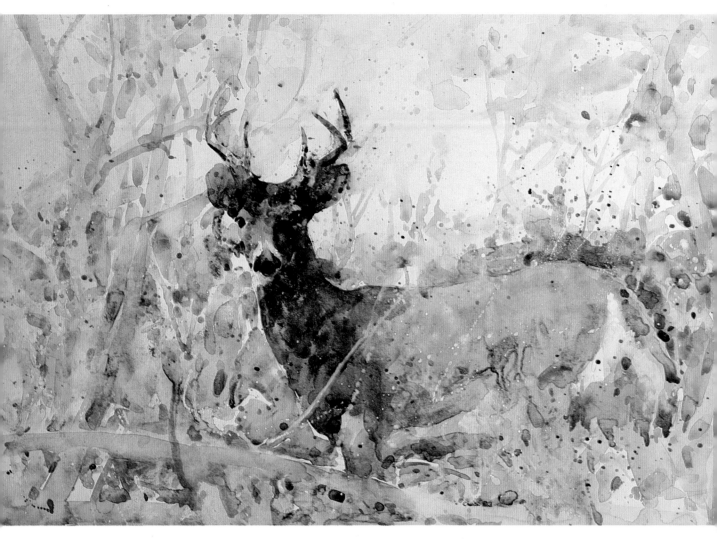

WHITE TAIL
Watercolor on Fabriano Artistico 140-lb.
rough paper, 22 × 30″ (55.9 × 76.2 cm).

Here I've used the principle a bit more subtly. This is an example of creating focus more with value contrast than with hard versus soft edges, my darkest dark forming not a negative shape, as in *Reverie*, opposite page, but the positive shape of the deer's head. The blurred areas are managed with closely related values.

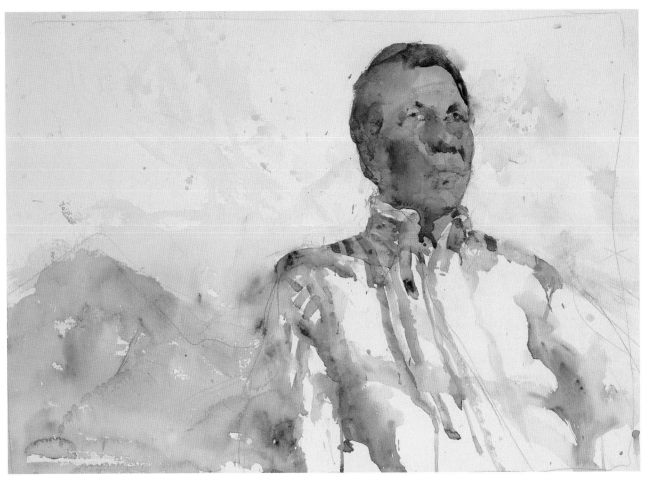

NATIVE AMERICAN
Watercolor on Fabriano 140-lb. rough paper, 15 × 22″
(38.1 × 55.9 cm).

On one side of the model's head I've articulated small shapes and apparent divisions between them—in other words, details that attract the eye. On the shadow side I simplify; details are less in evidence because I've generalized this area into a single shape.

SAN MIGUEL
Watercolor on Fabriano 140-lb. rough paper, 23½ × 18¾″ (59.7 × 47.6 cm).

This painting was done on site. The figure grouping in the left and center foreground constitute my "effect"; I completed this whole section before continuing on. Compare the degree of finish and detail in the figures with the right-hand wall of the cathedral, where I lightened values and did away with detail. Finishing the figures first rather than working throughout the whole composition helped me judge what needed to be done elsewhere. I painted as much from the finished part of my picture as I did from the scene before me.

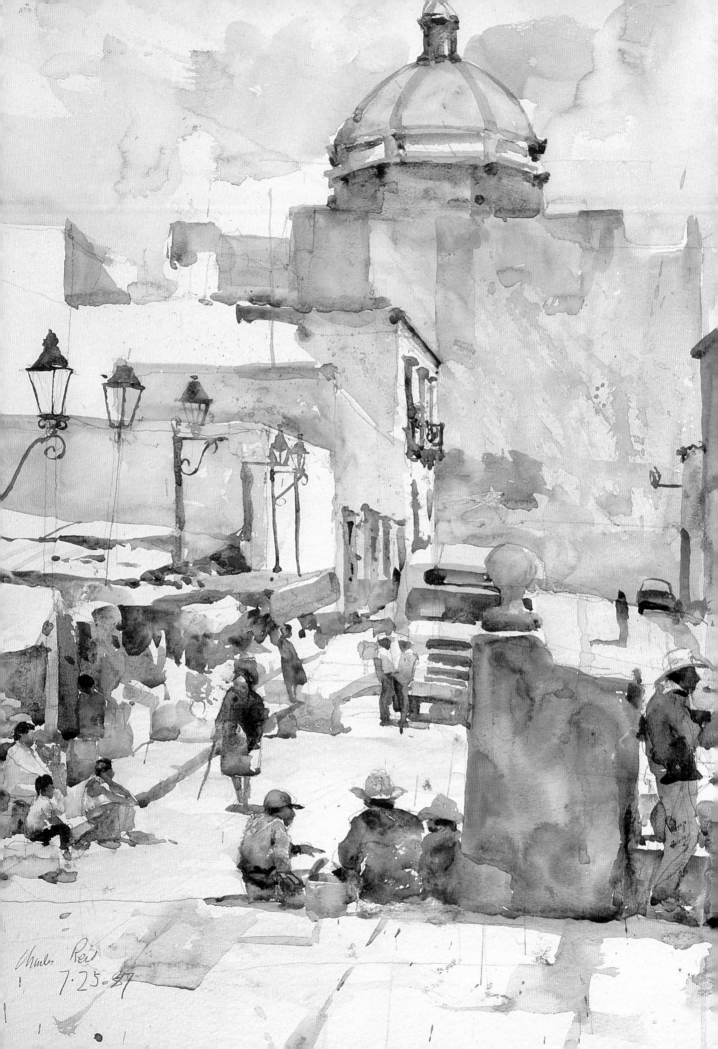

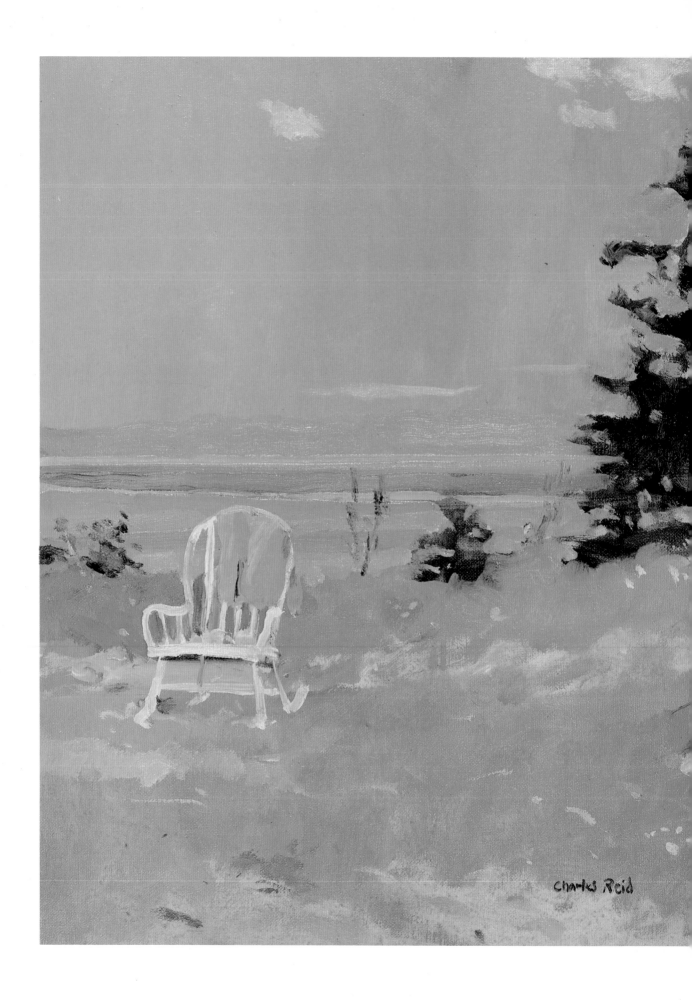

UNDERSTATING YOUR SUBJECT

OUR PORCH, BACCARO
Oil on canvas, 18 × 20" (45.7 × 50.8 cm).

What's the real subject of this painting? Where does the eye go first—to the pink director's chair? What about the contrast between the light sky and the darker blue of the ocean—is that what your eye seeks out? Actually, this picture is pretty abstract. What seem at first to be distinct foreground, middle ground, and distance dissolve the more you try to read them as such. Look at how the spruce tree next to the porch blends into the grass—I've blurred any separation between them, so the painting flattens out.

RUP'S CHAIR WITH PETER'S TOWEL
Oil on panel, 20 × 16" (50.8 × 40.6 cm).

Here, the chair is the subject and the center of interest, yet the "effect," the area of greatest contrast, occurs in the spruce tree at right. Sometimes it's better to draw the viewer's attention *away from* the subject. I knew you'd see the chair; it doesn't need underlining. If the tree were a light value like the chair or the chair dark like the tree, would the picture work?

A WORKSHOP SESSION

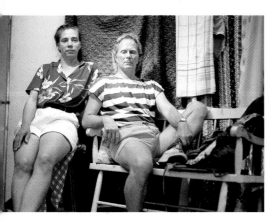

This two-hour figure-painting session was photographed during one of my workshops. My thanks to Roberta Clark for the step-by-step snapshots—she took them over my shoulder as I worked, and although they're not technically perfect, I think they give you a better sense of how I put a painting together than you might get from an artificial reconstruction of the process.

Think of your model as your partner in painting. In a class that's going to last for six hours, I have the model pose for twenty minutes at a time, with five-minute breaks in between, shortening the sessions as the day moves on.

Have your model simply sit. If I have two models, as here, I ask them to look in different directions. Always have a single, fairly strong light source. Flat or diffused lighting makes for difficult painting—there's no drama, no simple shapes; everything is a sea of detail.

Once you've set up the models, you must decide *before* you begin painting what your focus will be. Ask yourself what you really want to paint. Don't get involved with a lot of boring background.

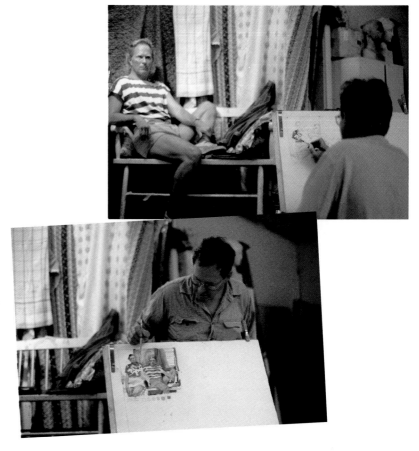

To get started, I have my students do a contour drawing to make a local value study. These two snapshots show me in the process of developing a value study from my contour drawing; the completed study appears on the facing page. I should add that the value study is not a final plan for the larger painting; I like the unexpected too much to map everything out. It's simply a way to hone my eye and help me understand what's happening with my subject.

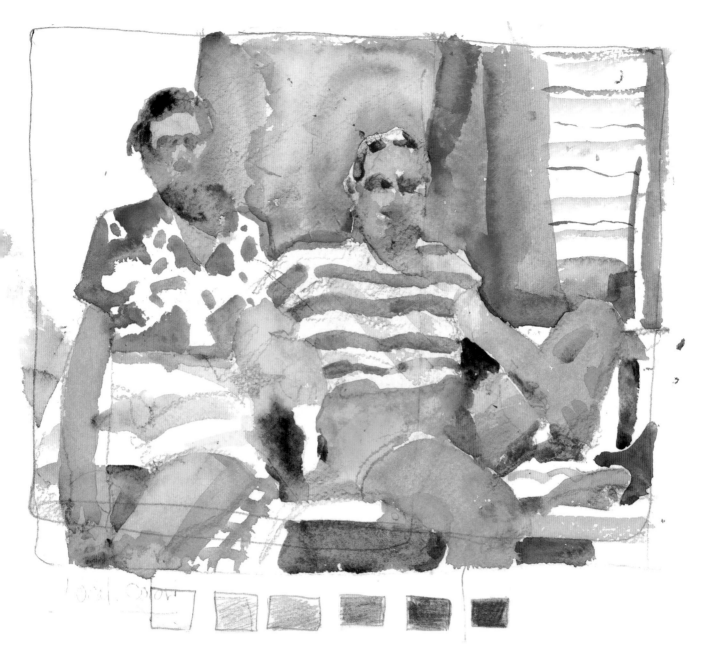

When you make a contour drawing, remember to travel across the page with your pencil, weaving the background, picture border, and figures together right from the beginning; never fill in a figure and then add a background as two separate, isolated thoughts. If a boundary is lost in shadow, leave it out in the drawing as a reminder to do the same in the painting stage. Make sure your figures don't float; connect each of them to at least three of the picture borders, and try to have half the shapes negative and half positive. Don't use a lot of background unless it interests you. And don't alter proportions just to get a whole figure in; instead, let part of the figure go off the page.

I make a six-value scale in pencil along the bottom margin of the drawing as a reference for the color values I paint in the figures and surroundings. In the photograph of the two models, opposite, light and shadow are most apparent in the faces—the light-value areas—while local color-value dominates in the shirts, background, and lower parts of the composition—the darker areas, where the spotlight's effect is less.

I asked the class to try to get the specific color-value of each area correct with the first wash. The second wash is only for adding shadow shapes. In strong color spots I used unmixed color—pure cadmium orange and yellow for Jon's shorts, and various blues for both model's shirts. (The blues look all the same here, so I'll try for more variety next time.)

I begin my painting with a contour drawing that fills the whole sheet of paper, eliminating much of the background and crowding the figures. As the photo at left shows, I start the painting with Jon's eyes, finishing the one on the lighter side of his face first. I work my way down the center of the face, aiming to get my final colors and values on the first try. I soften and connect, leaving areas of white paper and harder edges where I find light hitting the lower lip, the bridge of the nose, and the cleft above the upper lip. The nostrils are darker and done wet-in-wet. The photo at right shows the completed head.

 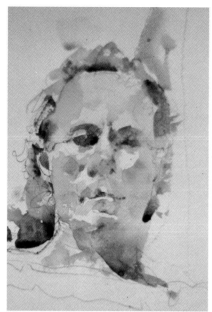

At left, I work my way down the arm with a negative dark to make it pop out, connecting this negative shape with the cast shadow under the sleeve. I do the same with the shadow side of the arm, running into shadow on the shirt and chair. In the photo at right, I add stripes to the shirt and paint the shorts, socks, and shoes, keeping things varied but still definite without making them look cut out and pasted down. I let some adjacent areas work together wet-in-wet.

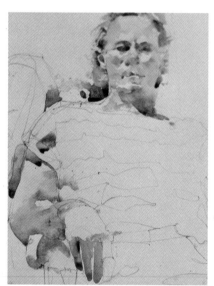

For the skin tones I use cadmium red light, raw sienna, and cerulean blue. I like to concentrate on one person at a time, get major stuff solved and then feel confident as I move on. Jon seemed to come out okay, so I have spirit. In the right-hand photo I've moved on to Sue, again starting with the eye shape on the illuminated side of her face. The light sculpts the structure of the head. That's what I paint: the pattern of light and shadow shapes. Accuracy and understanding the planes of the face are the whole ballgame.

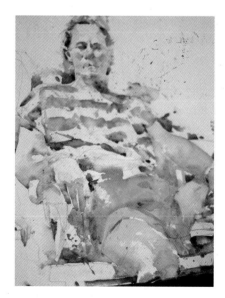

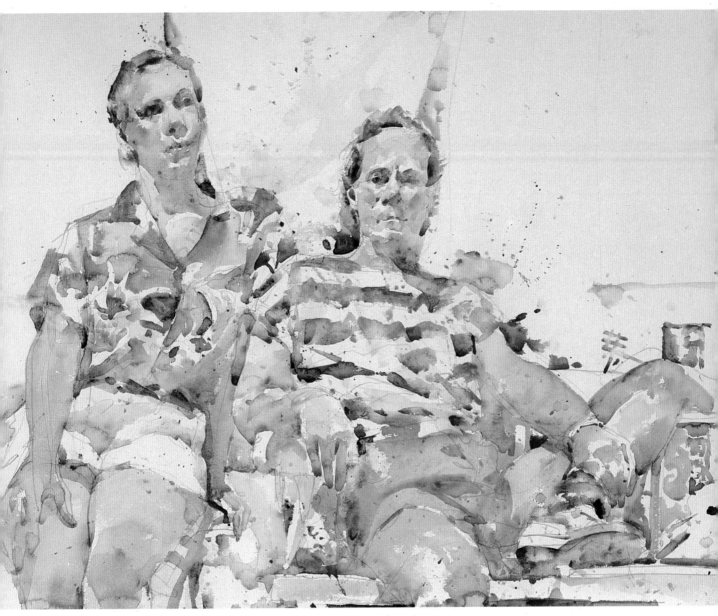

I like to create the sense that my figures are woven together, with easy transitions and connections in some places, saving my separations for the play of light around lovely form. I painted *Sue and Jon* with the assumption that I had only one chance to get it right. There's no corrective overpainting here.

I used an oil-painting method in most of this picture. The heads, for example, were painted darks first—the features and hair. I left the light areas as white paper. The shadows weren't important, so I painted the blue in the shirts first, stating the patterns as precisely as I could with the first pass of the brush. (If I'd had dominating shadow shapes in these areas, I'd have painted them first and then added the stripes.) Remember: Articulate dark shapes first, then correct color and value (as in alla prima oil painting), winding up with the softening of whatever edges call for it.

SUE AND JON
Watercolor, 22 × 30" (55.9 × 76.2 cm), courtesy of Munson Gallery.

SKETCHBOOKS

Sketchbooks have become my art school. I started years ago with a wavery line that slowly became surer as I aimed for careful shapes and composed scenes. Actually, I've developed my way of composing, drawing, and applying watercolor in my sketchbooks.

I prefer sewn, hardbound sketchbooks; somehow they lend an importance to the work that fills them. Generally I use a size of about 10 × 14″, with cold-pressed 90-lb. paper. (I occasionally also use spiral-bound pads of watercolor paper.) If I'm going to be working in watercolor, I draw with a sharp #2 pencil; if I'm not adding paint, I use a fine-point felt-tip pen or ballpoint. For watercolor I like round brushes, preferably sable (Raphael is a favorite brand of mine); #2, 4, or 5 are the best sizes for the careful work sketchbook painting demands. I use a folding metal palette with either half-pan cakes of watercolor or tube colors.

In my basic method, I start with a figure and draw it carefully, including adjoining negative shapes. Most of these kinds of pictures are done with the idea that I have only minutes to complete a figure before he or she moves.

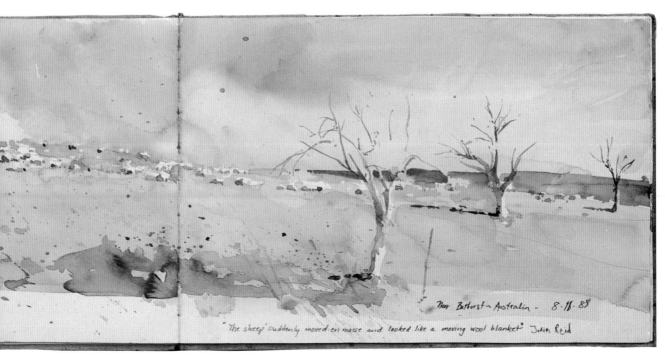

Near Bathurst ~ Australia ~ 8·11·88

"The sheep suddenly moved en masse and looked like a moving wool blanket" Judith Reid

INDEX

Edited by Marian Appellof
Designed by Jay Anning
Graphic production by Hector Campbell
Text set in 11-point ITC Berkeley Oldstyle Book